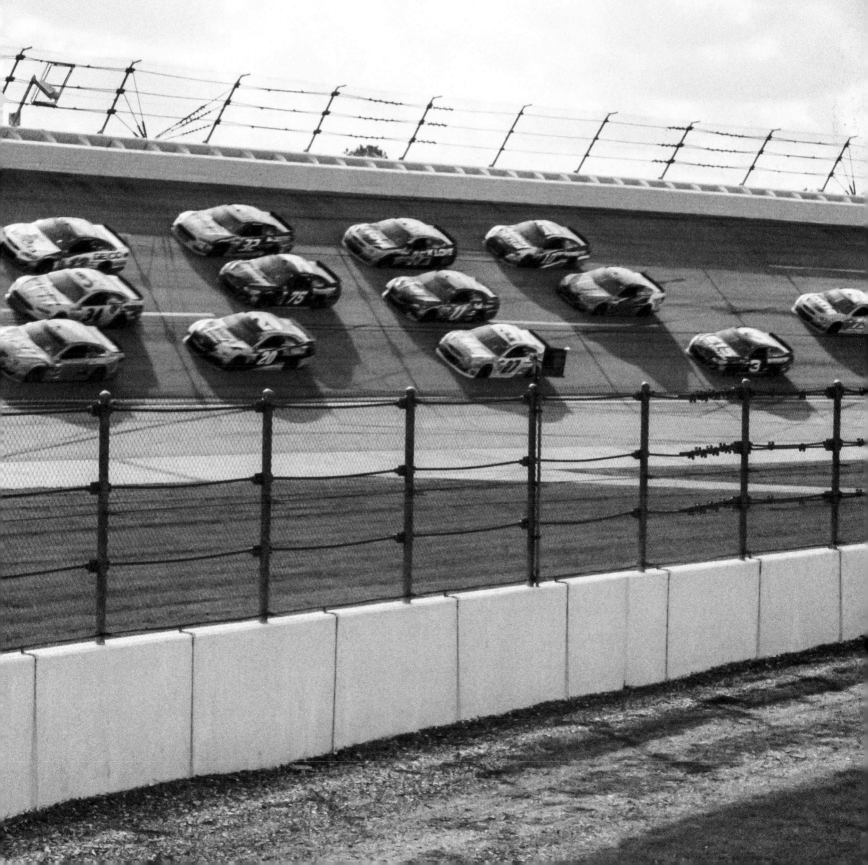

SPIRIT OF THE SOUTHERN SPEEDWAYS

SPIRIT OF THE SOUTHERN SPEEDWAYS

PHOTOGRAPHS BY HUNTER BARNES

R|A|P

REEL ART PRESS

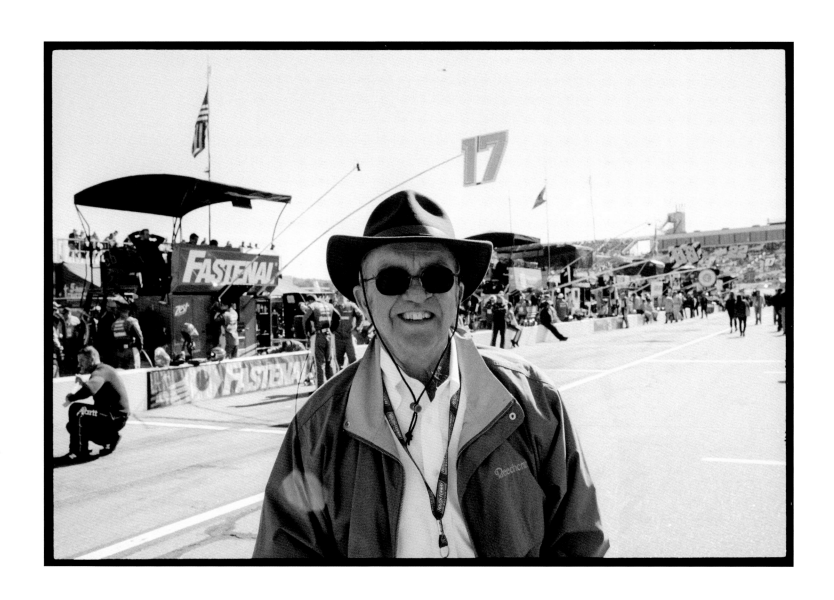

JACK ROUSH

THIS BOOK IS DEDICATED TO MICHAEL DINGMAN

SPIRIT OF THE SOUTHERN SPEEDWAYS

Tailwinds of a speeding eagle

From the infield to the stands, the screams of the fans fill the sky
A village that will feed you, a family that will travel to the next town again

Rolling thunder of the Southern tracks, a rumble of engines set fire ablaze
The smell of rubber peels like lightning as drivers flash inches together to ride their dream

The world of speedway racing reaches so many layers deep
Riding in for miles, approaching a spirit at each track words cannot speak

A time and place where many have been before today
A walk through where I was invited, showing the spirit of the Southern speedways

HUNTER BARNES

DAYTONA

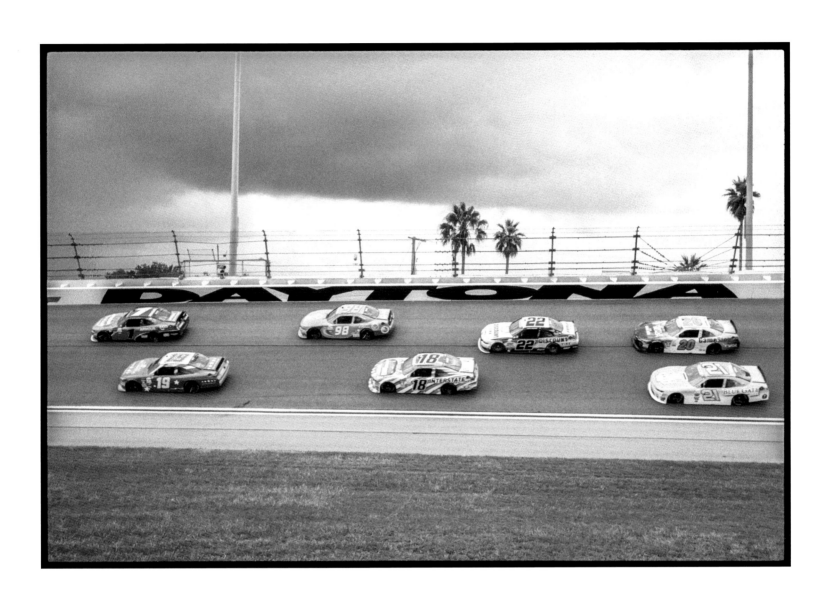

TREE DOG

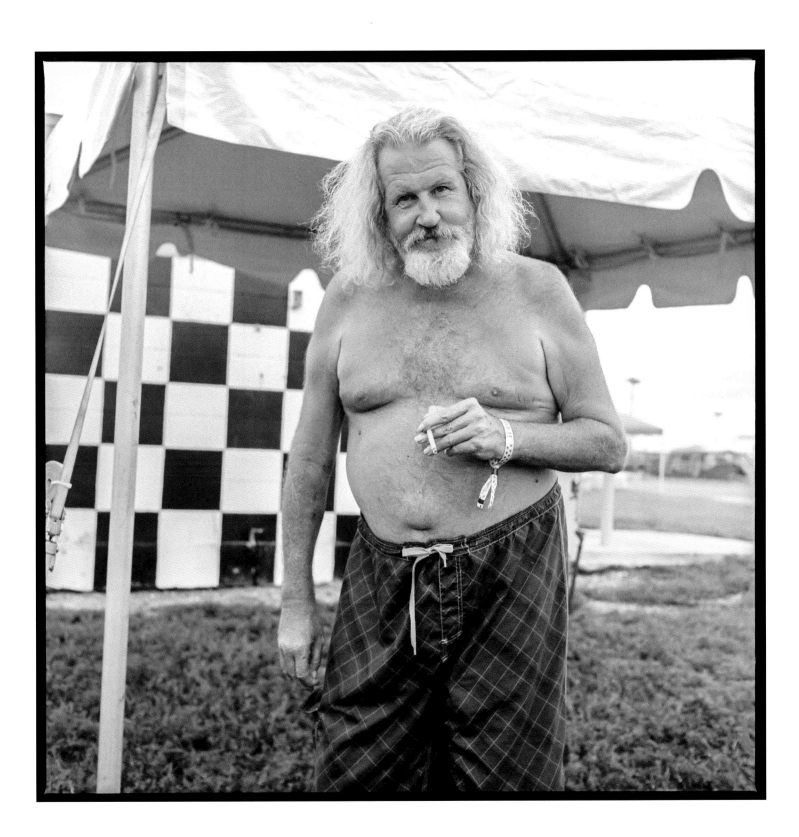

BOBBY ALLISON

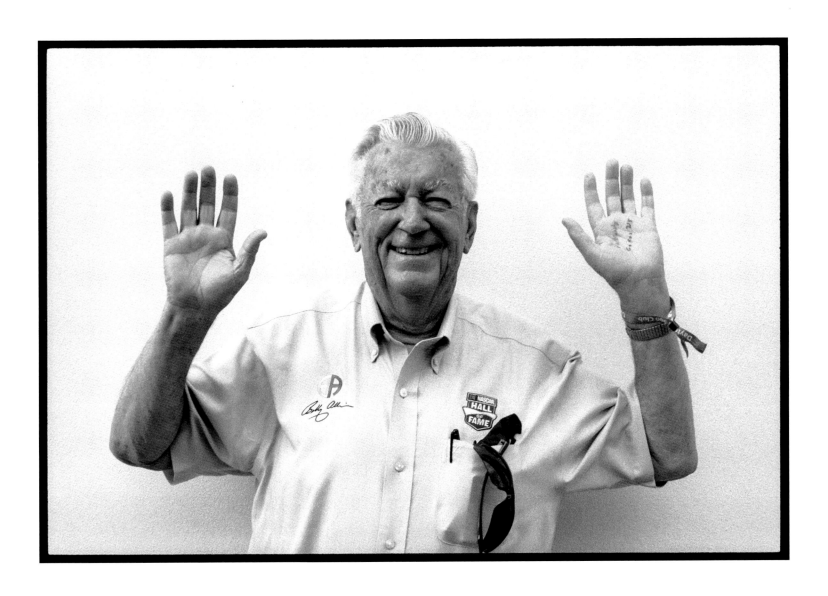

MASON

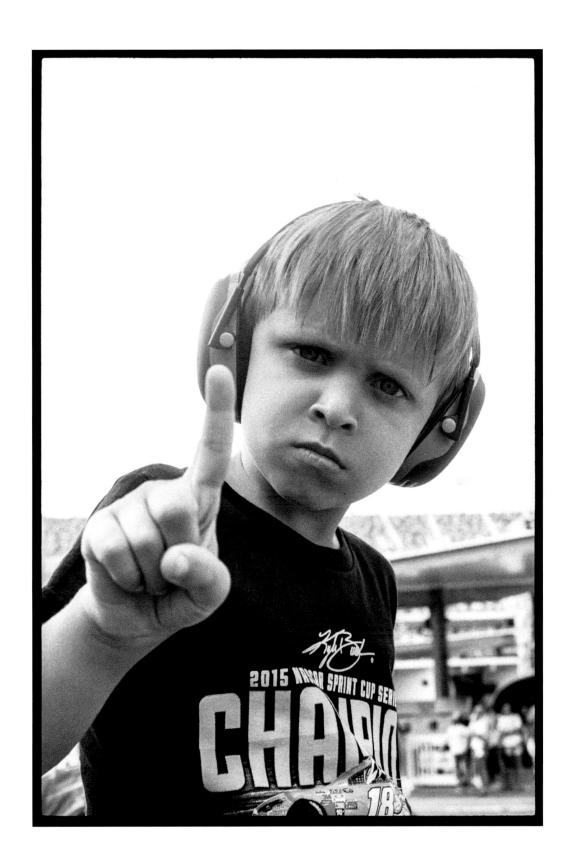

TAILWIND

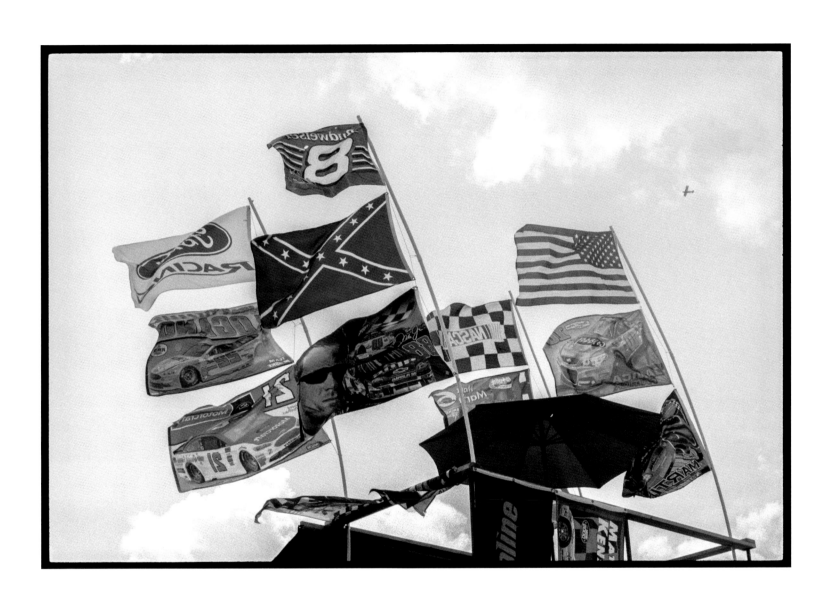

NUGGET

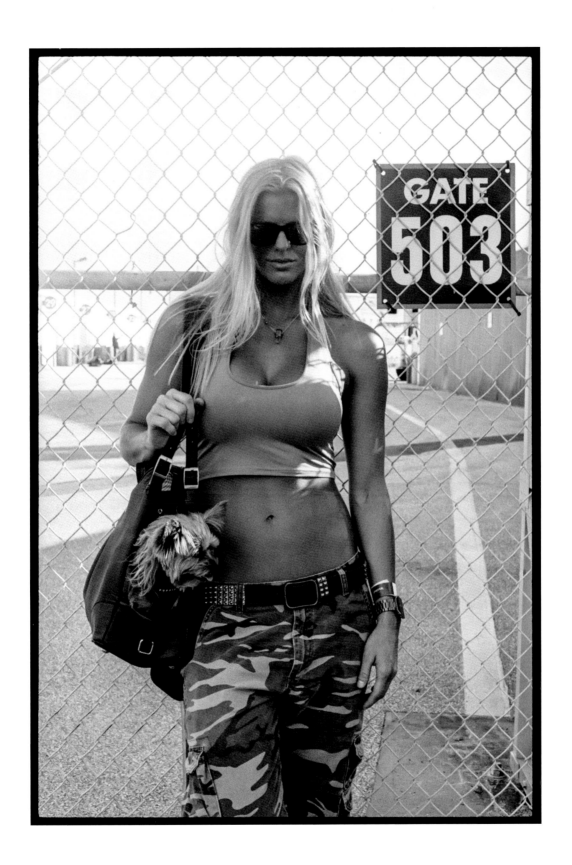

DAYTONA INFIELD

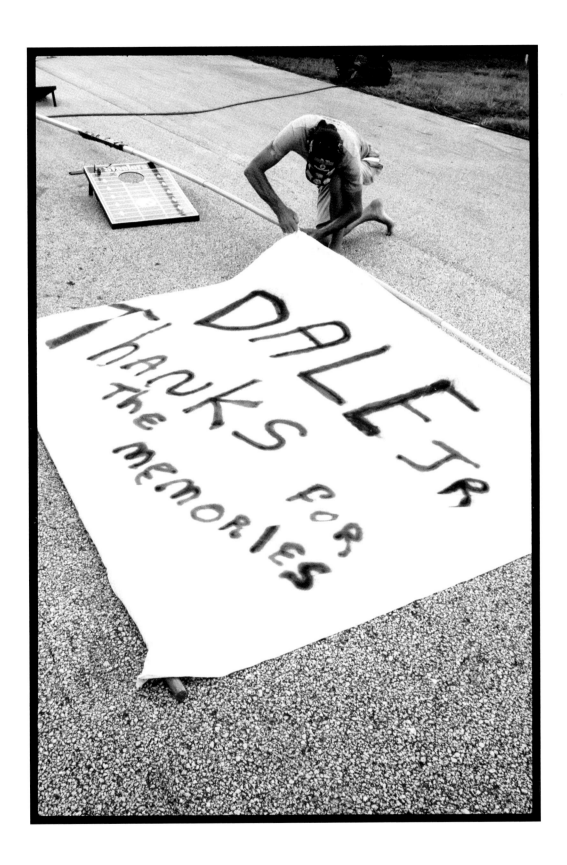

ALLISON

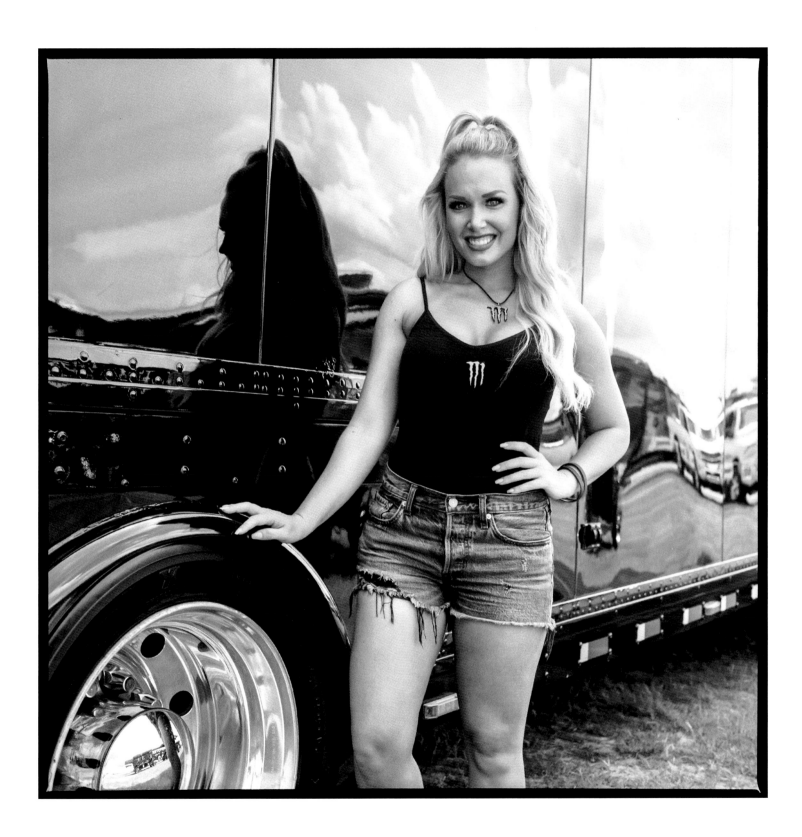

TURN 4

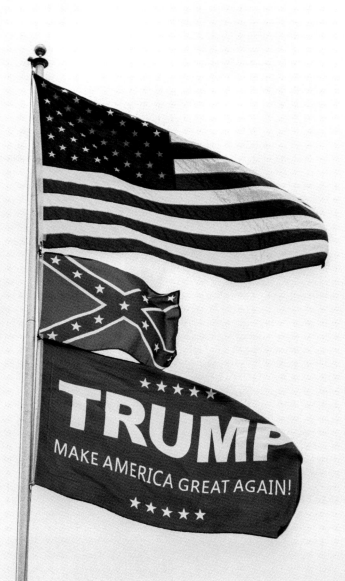

BRISTOL GRANDSTANDS

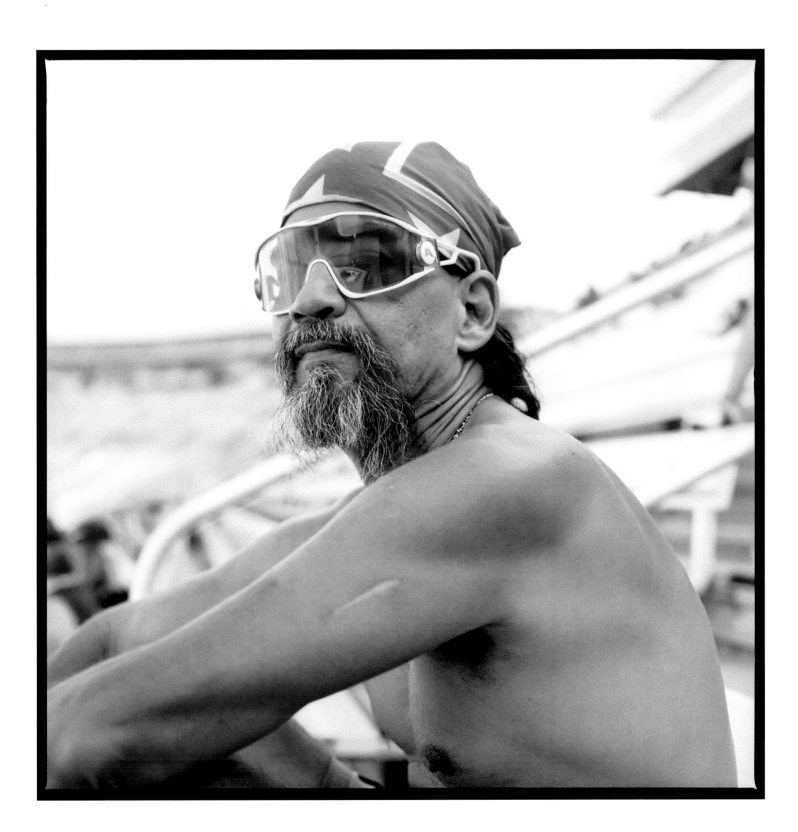

BANJO NEIL

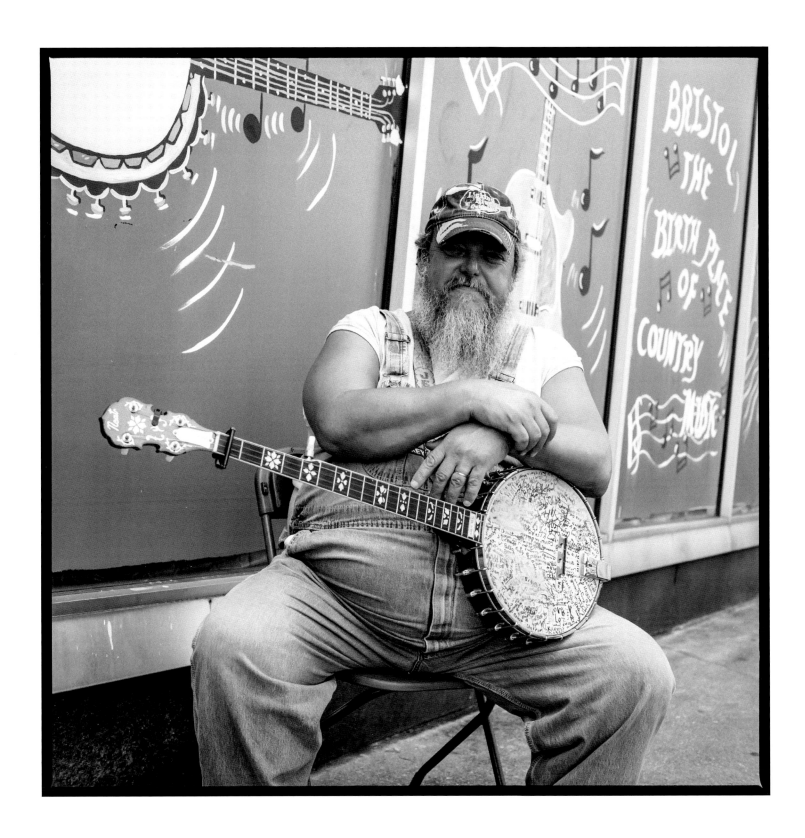

DOLLY

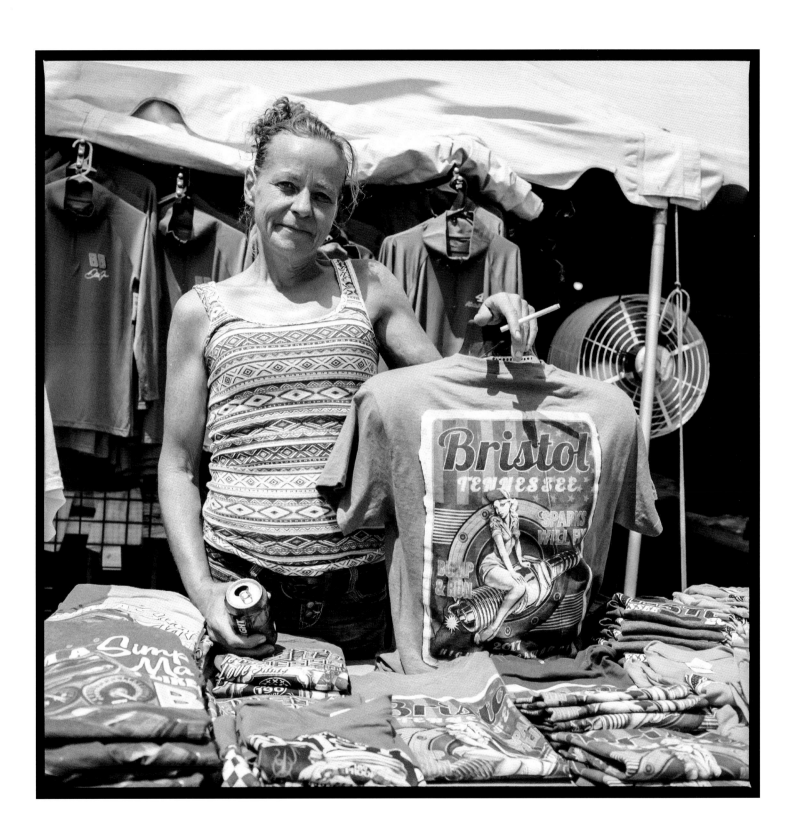

NASCAR WALKING STICK

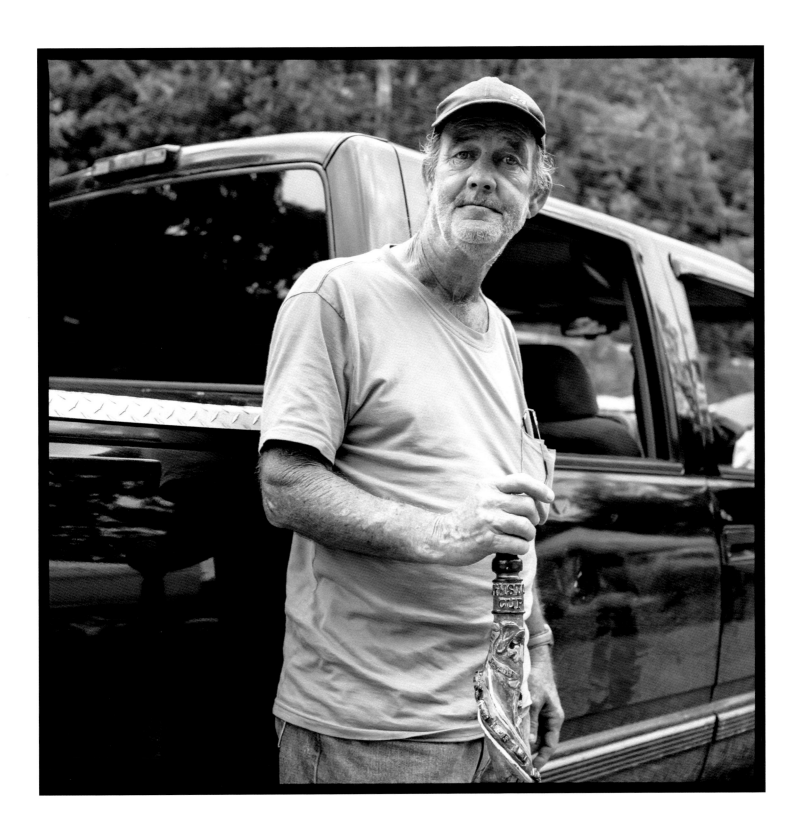

K AND K KOLLECTIBLES

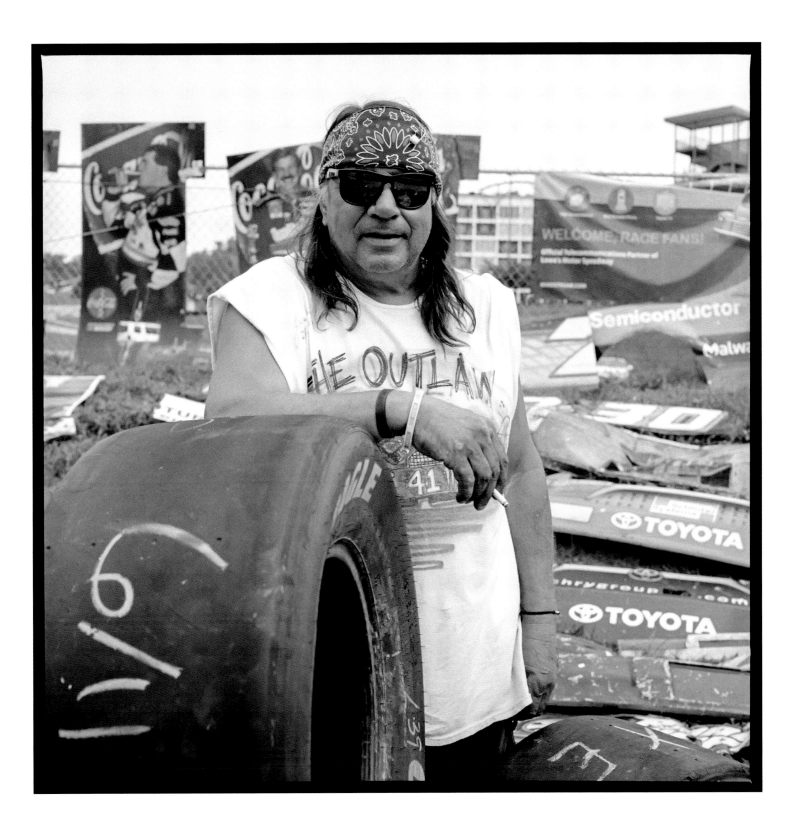

TRAVIS TILLER

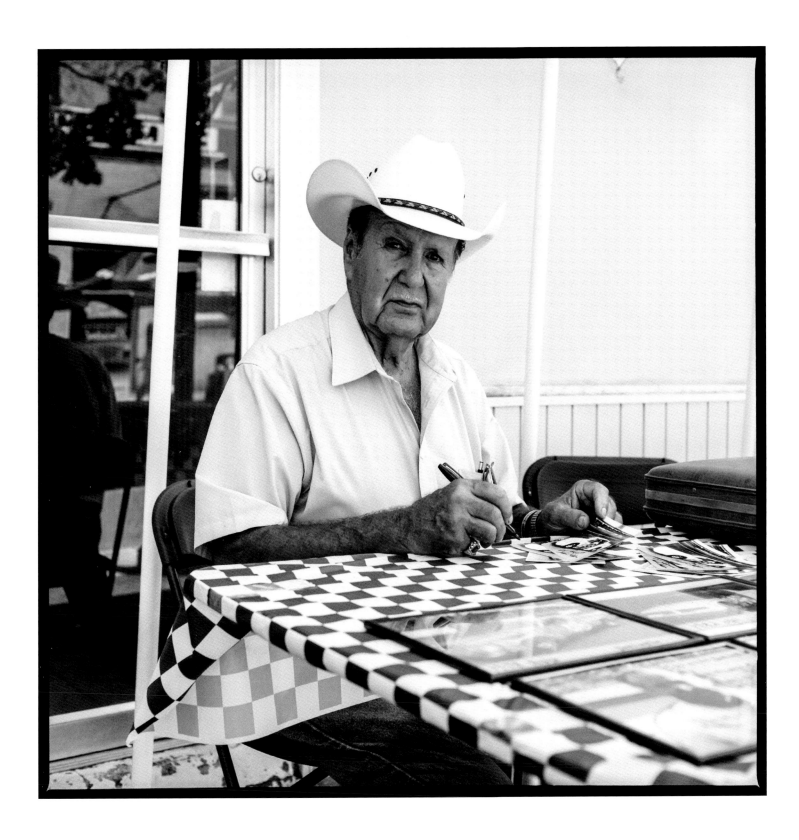

GENTRY CAMPGROUND

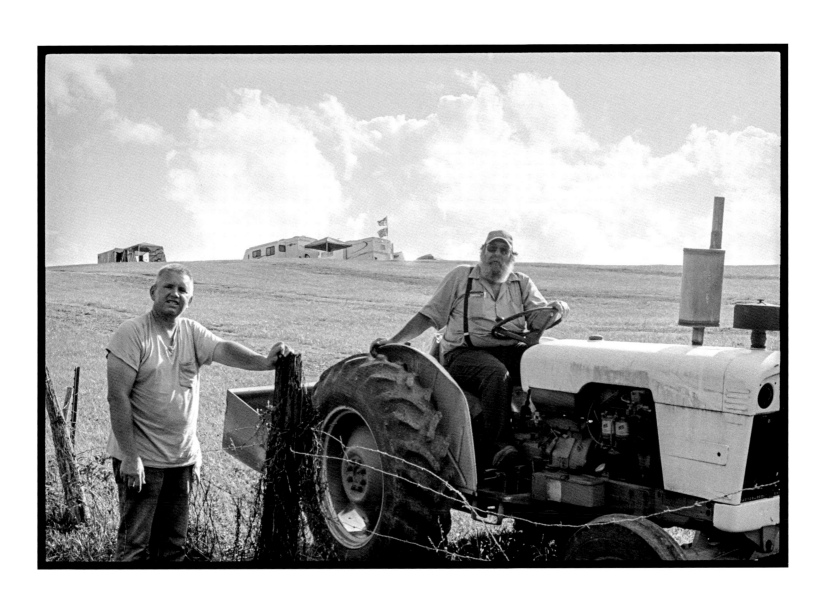

SMOKIN PETE'S BARBEQUE

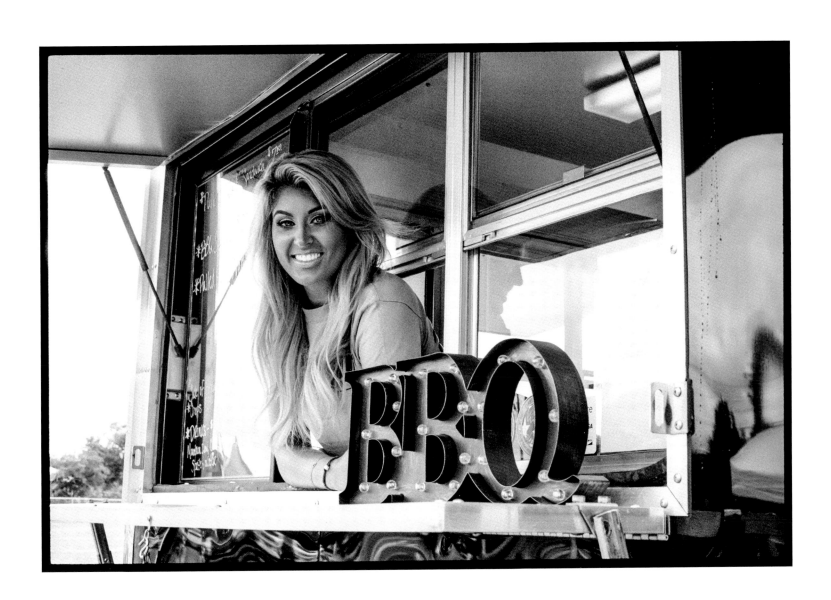

BROTHERS' LOVE

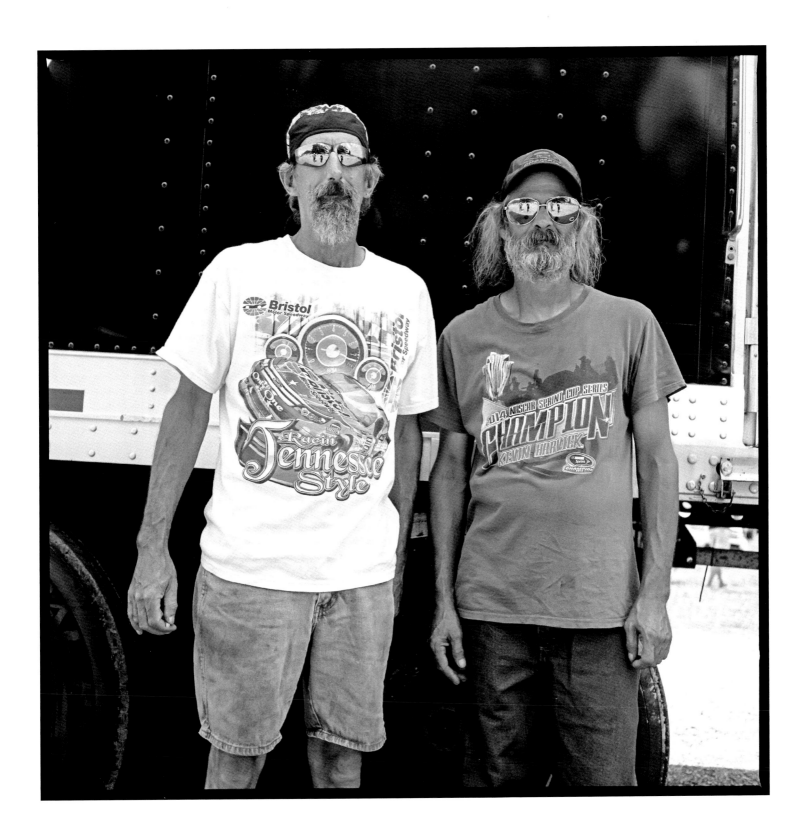

GANASSI PIT CREW

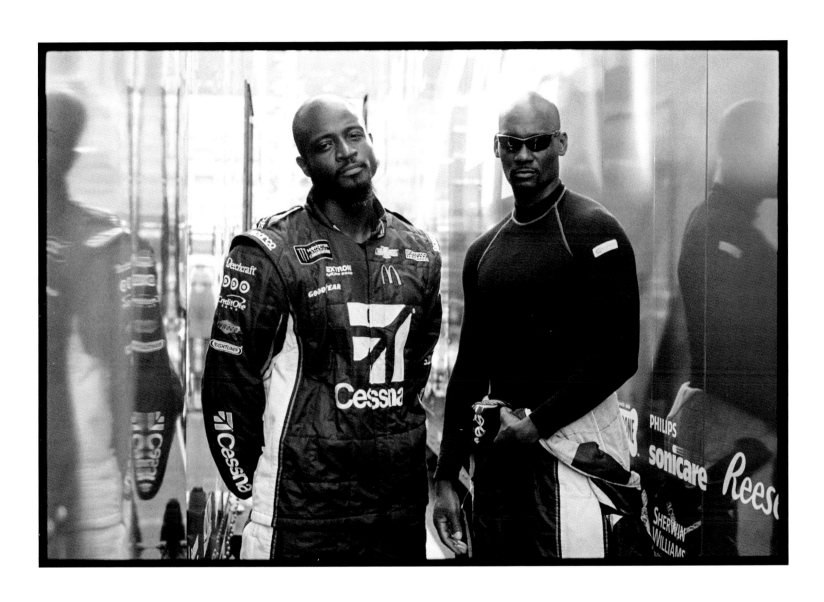

BRISTOL

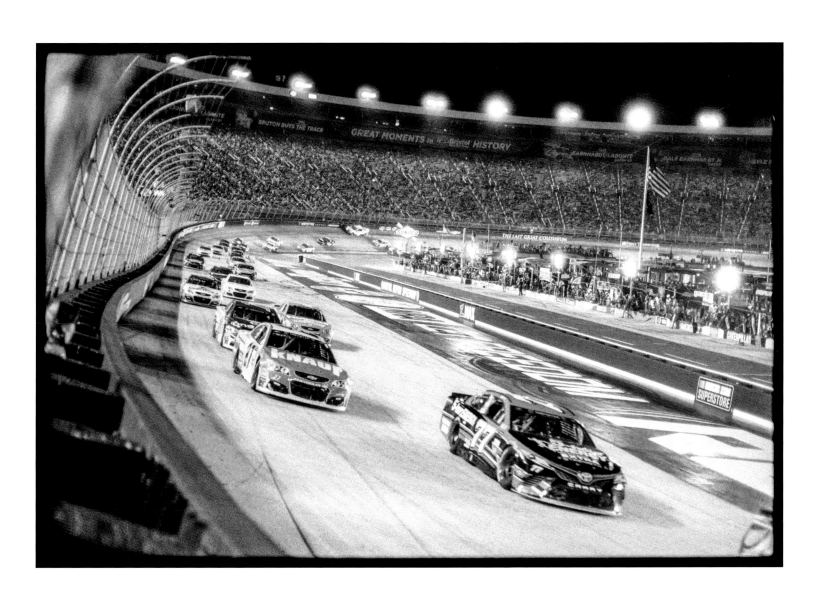

THE LAST GREAT COLOSSEUM

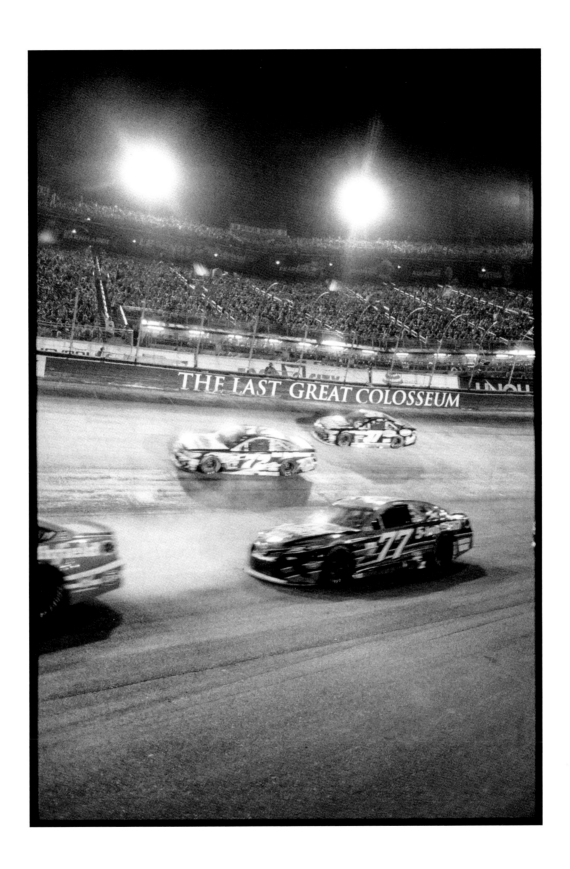

DARLINGTON INFIELD

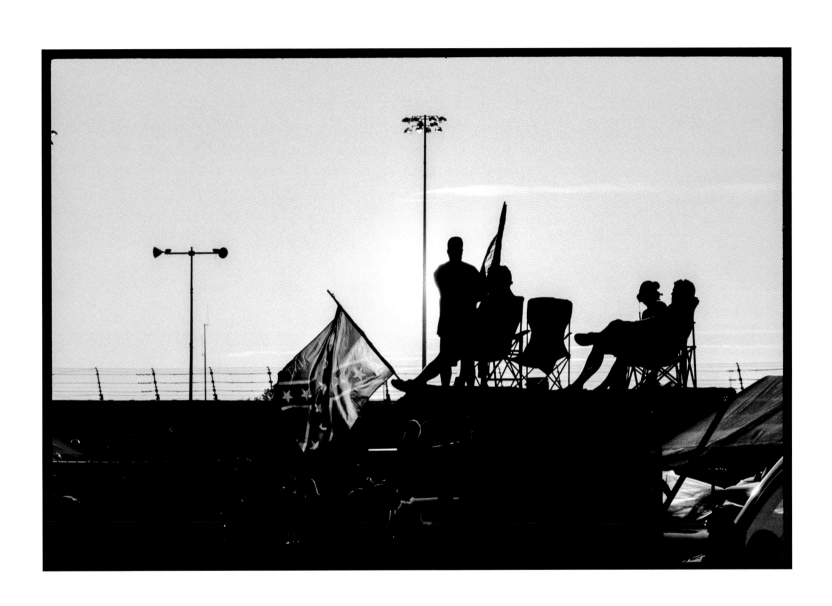

SOUTHERN 500 CAMPGROUND

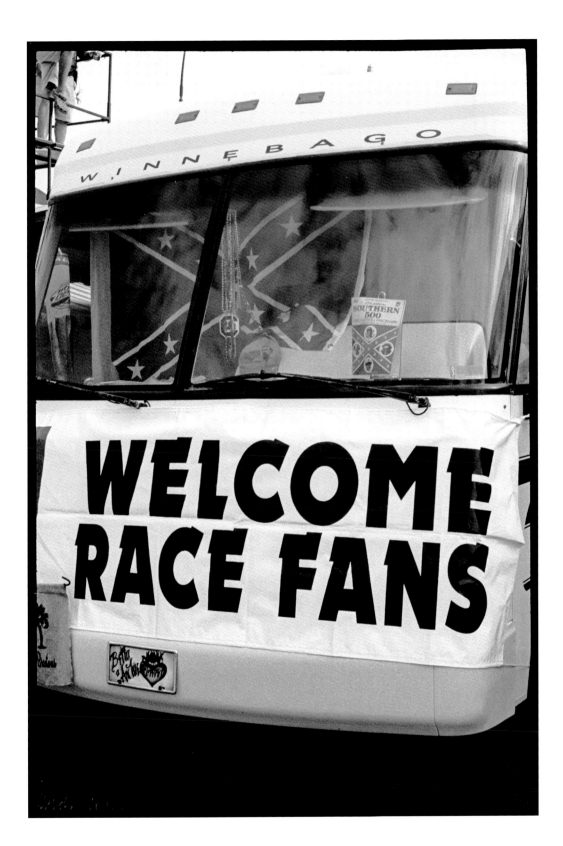

THE NEIFFERT BOYS

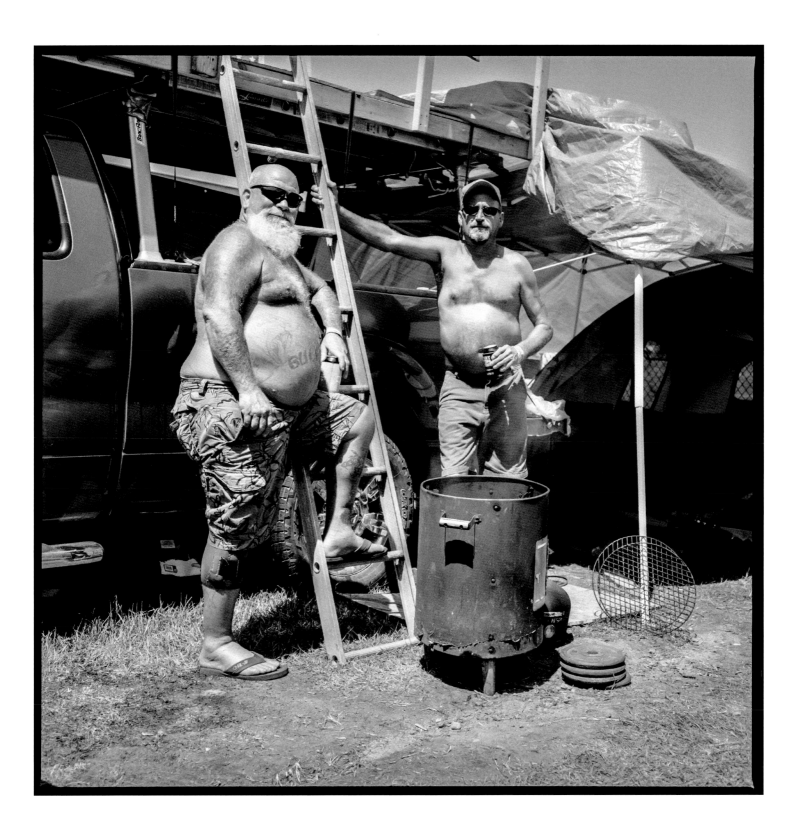

THE WALKER FAMILY

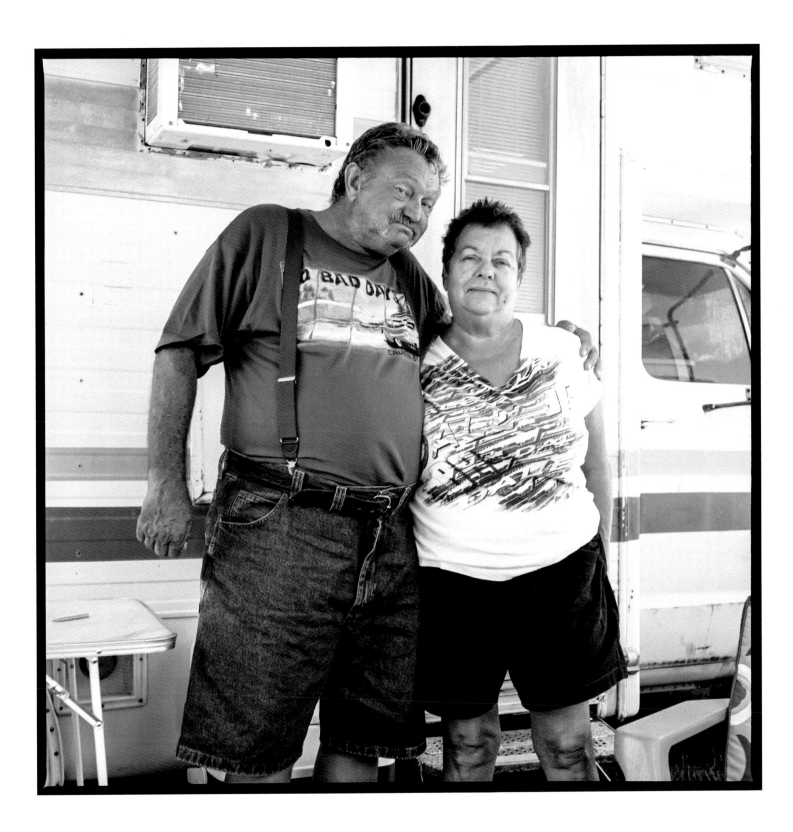

PARADISE PARKING LOT

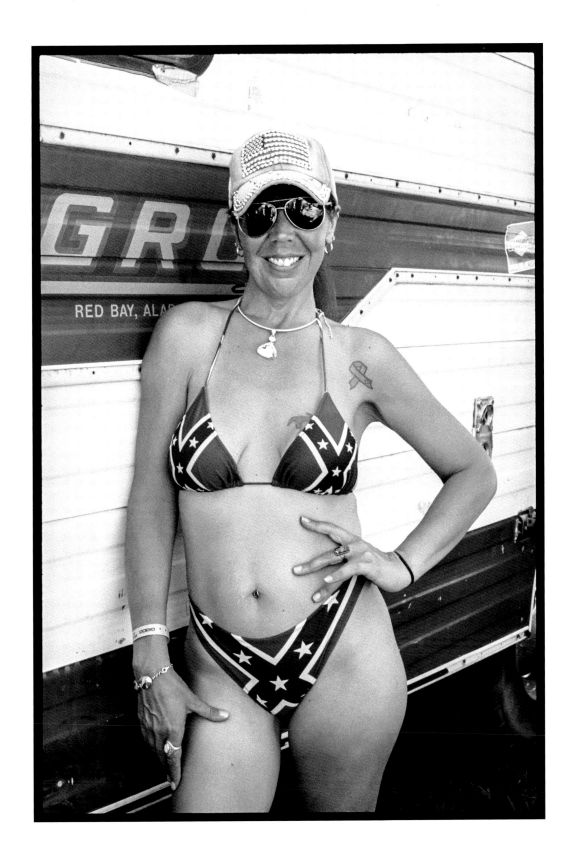

DARLINGTON

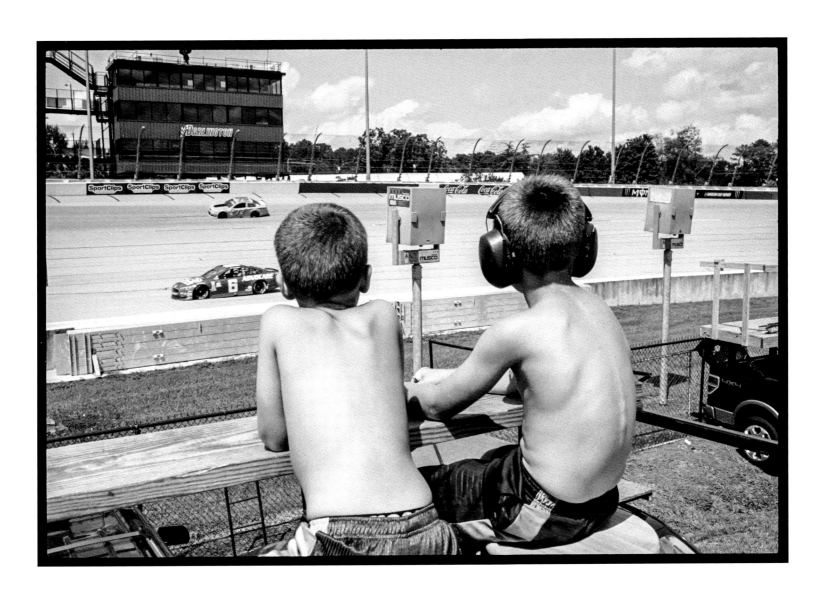

LEONARD WOOD

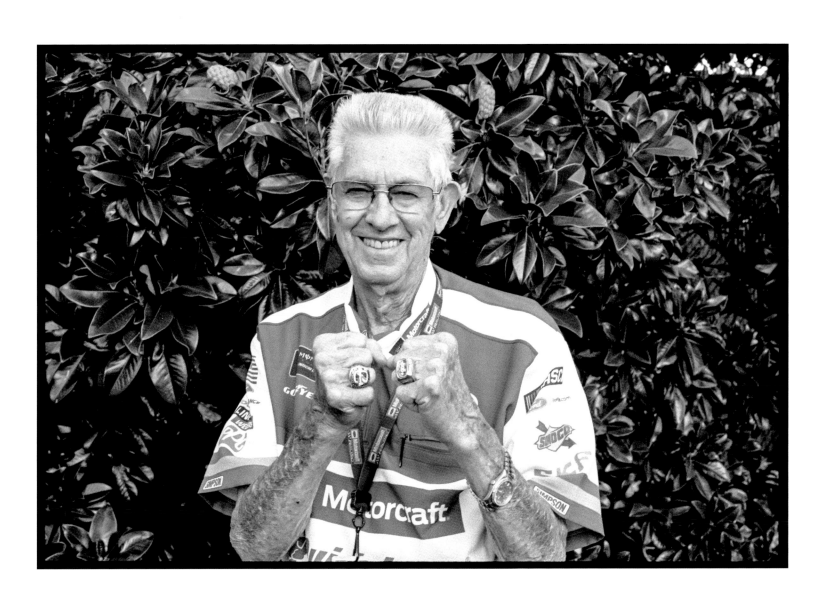

KYLE LARSON

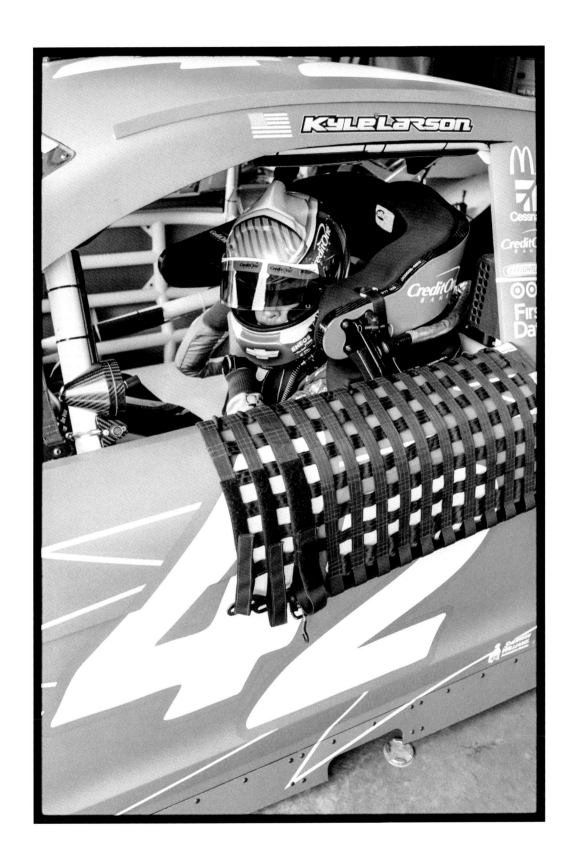

RYAN BLANEY

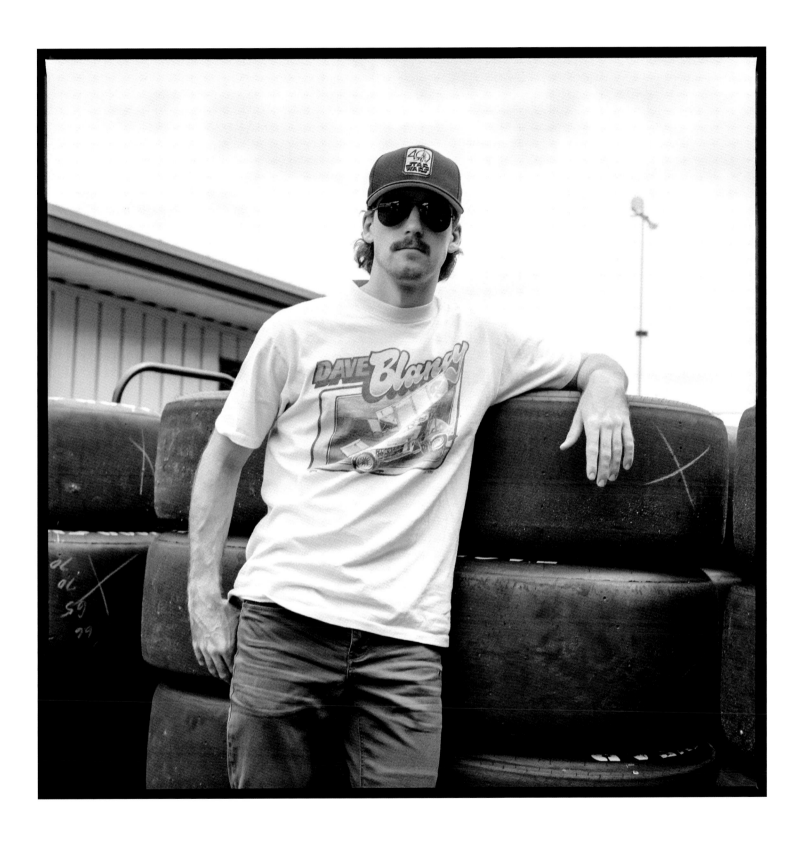

AUSTIN AND WHITNEY

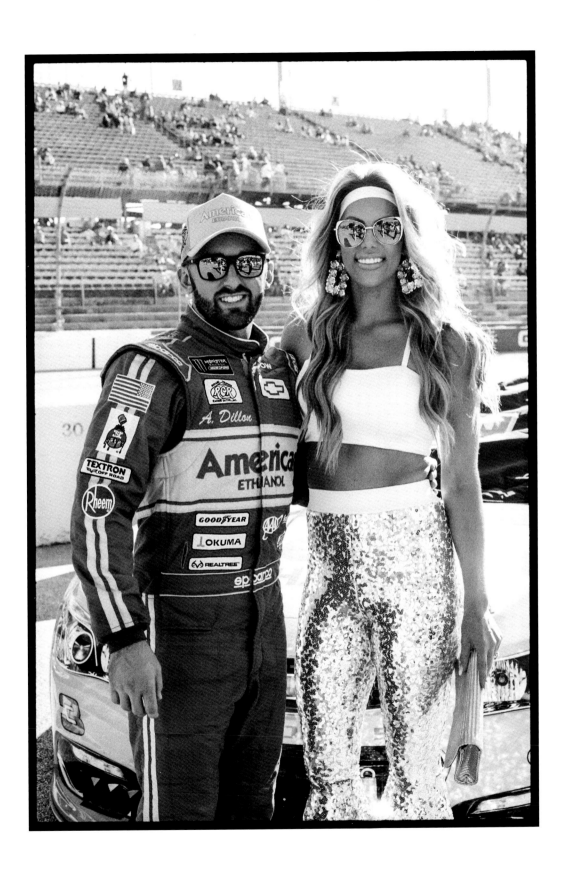

NED JARRETT

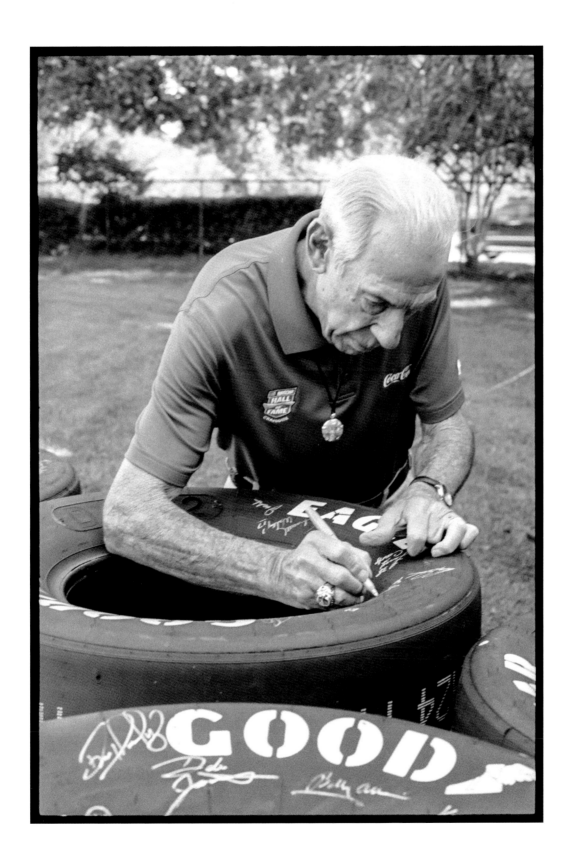

CHARLOTTE MOTOR SPEEDWAY

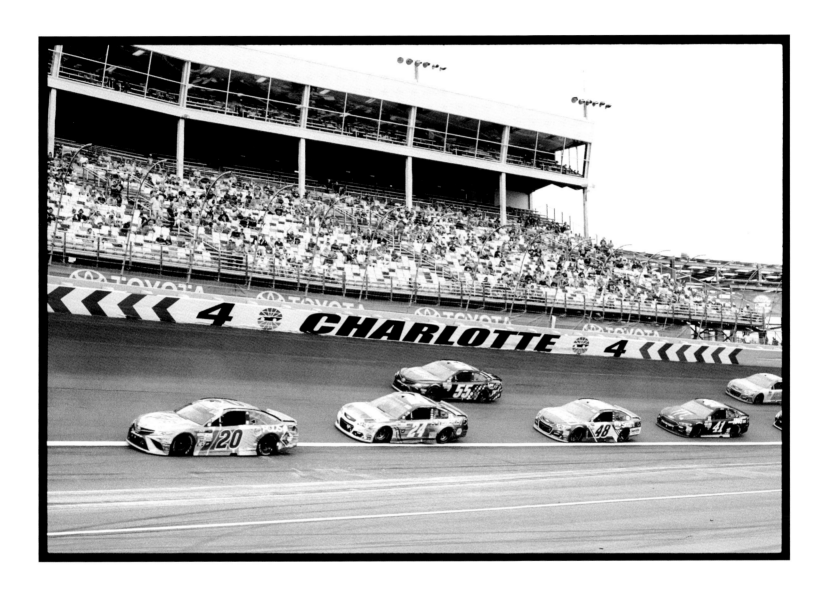

PIT STOP

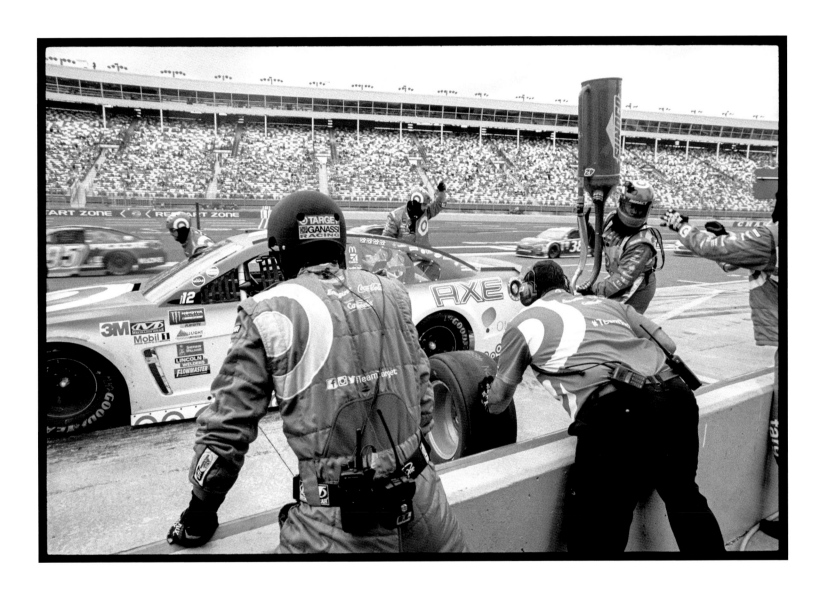

GANASSI GARAGE

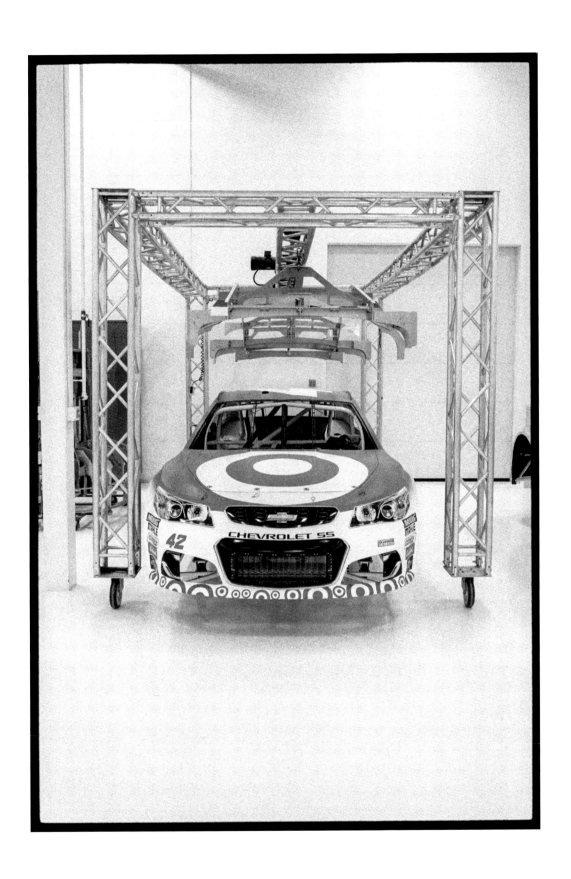

FUEL LINE

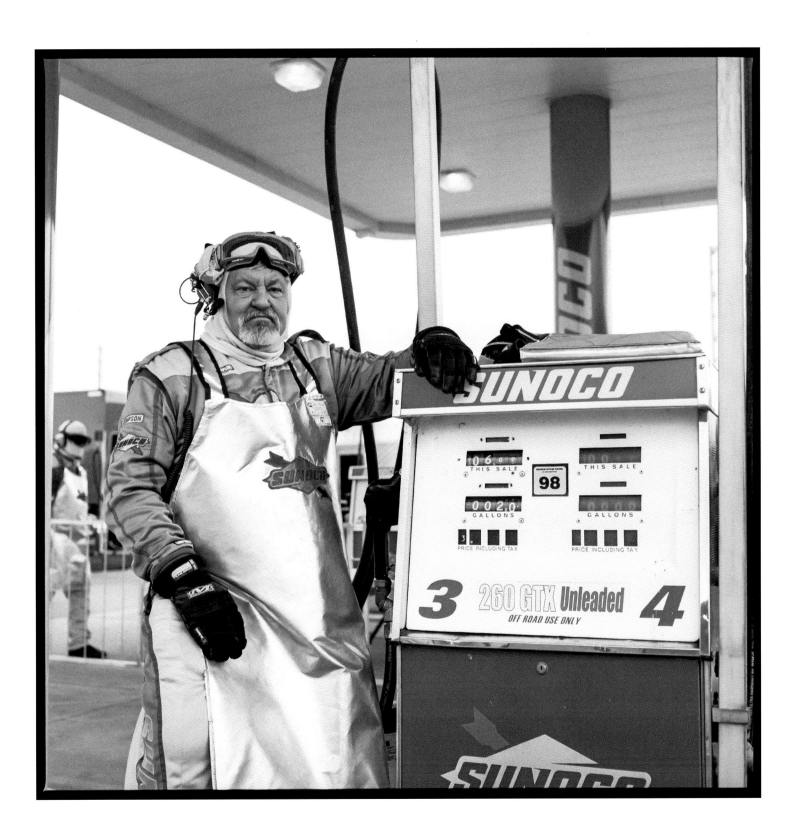

MR. PAUL CALL

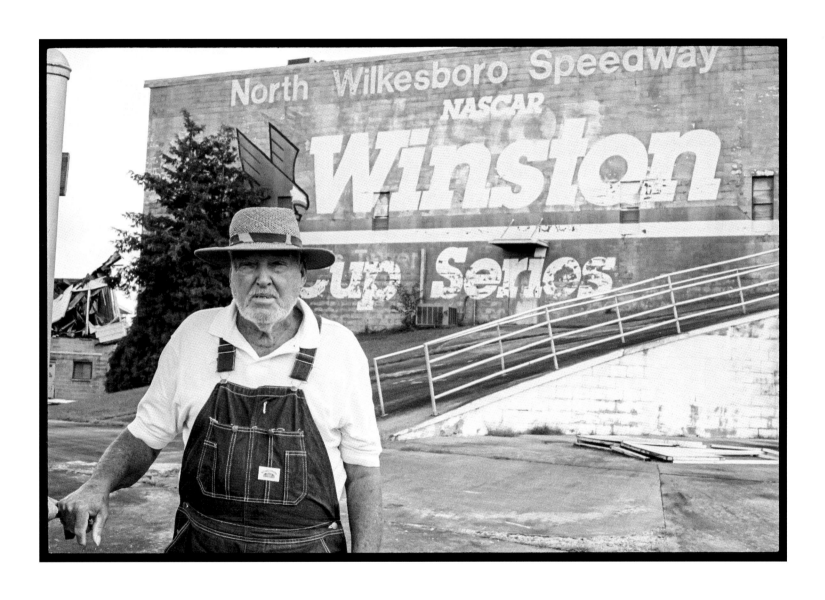

JUNIOR JOHNSON

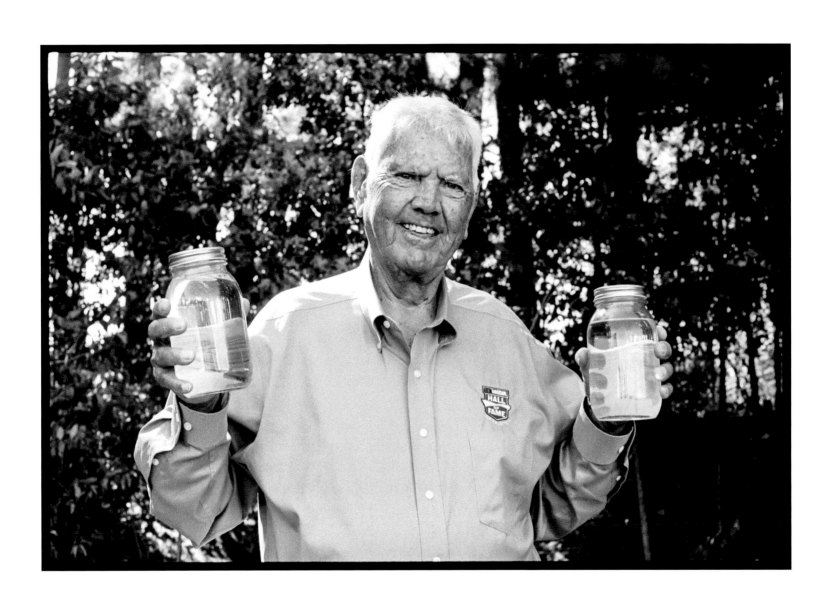

RICHARD PETTY

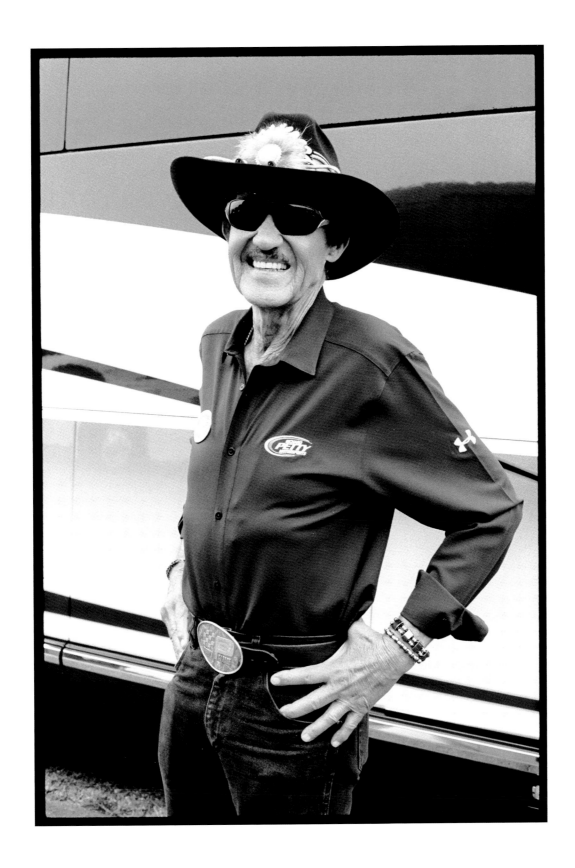

CAROLINA

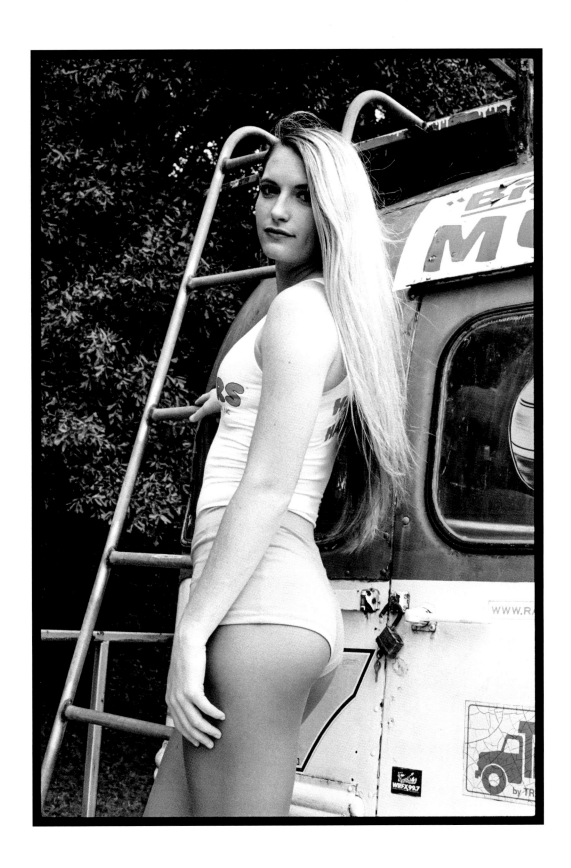

BEFORE THE RACE

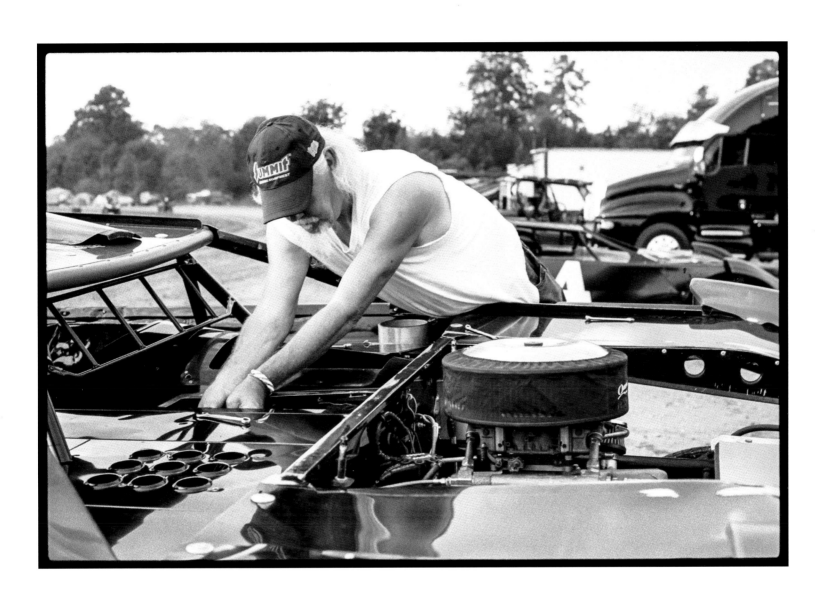

RED FARMER

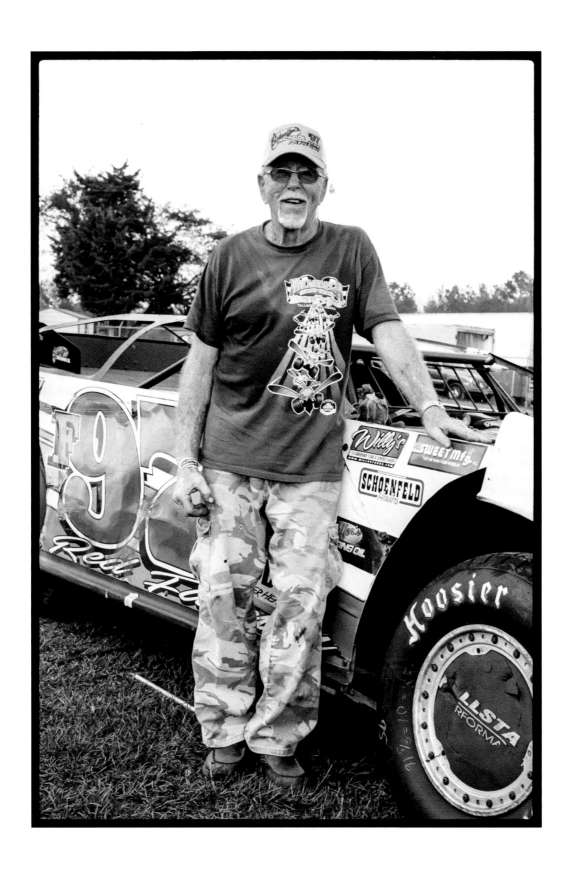

TICKET BOOTH

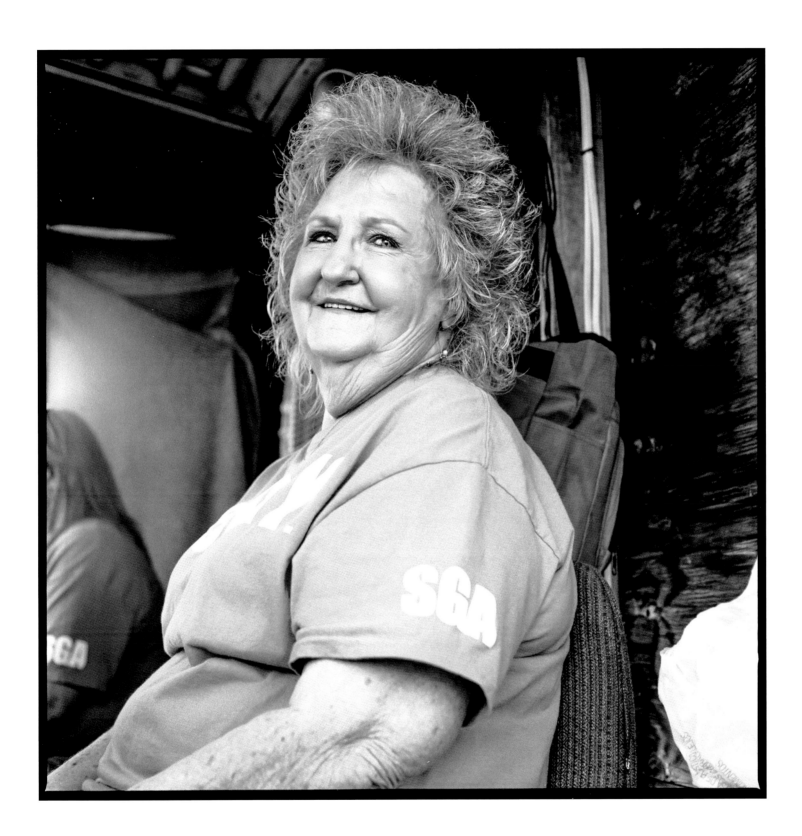

COLE

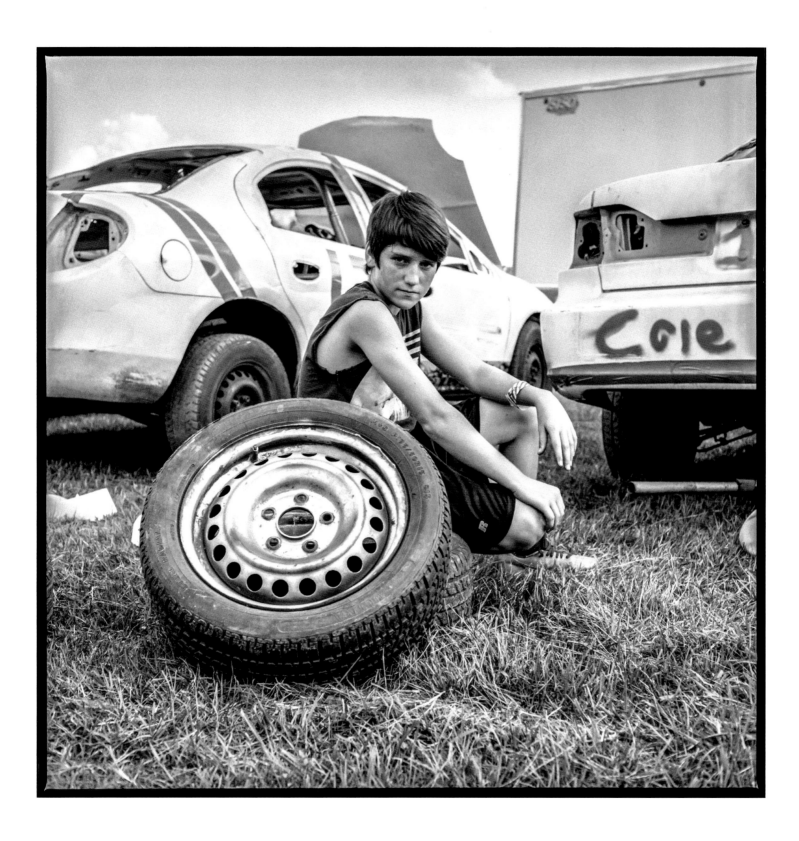

HALEY

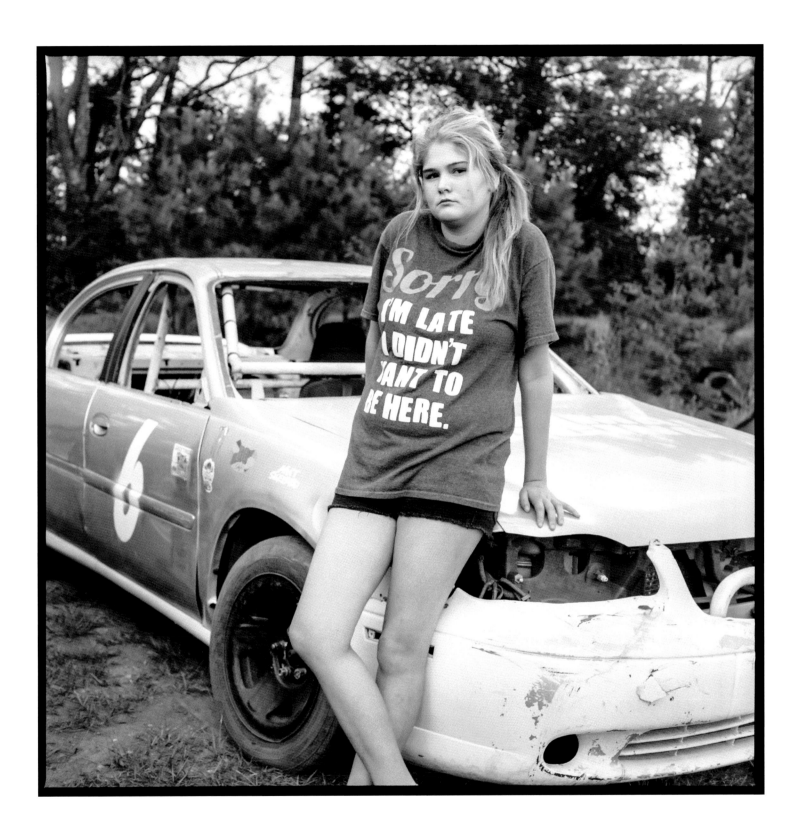

DIRT TRACK RIDER

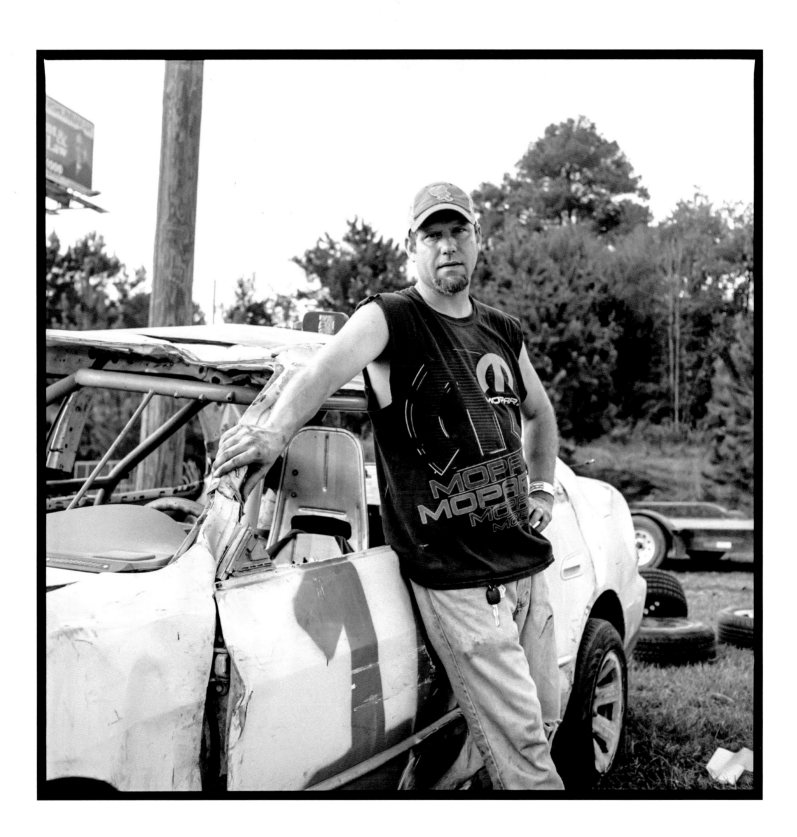

DIRT TRACK

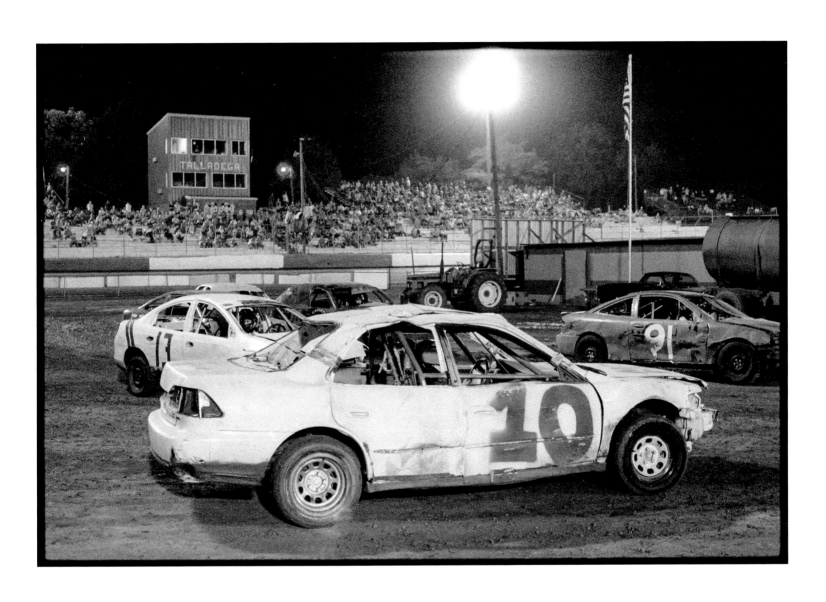

TALLADEGA SHORT TRACK

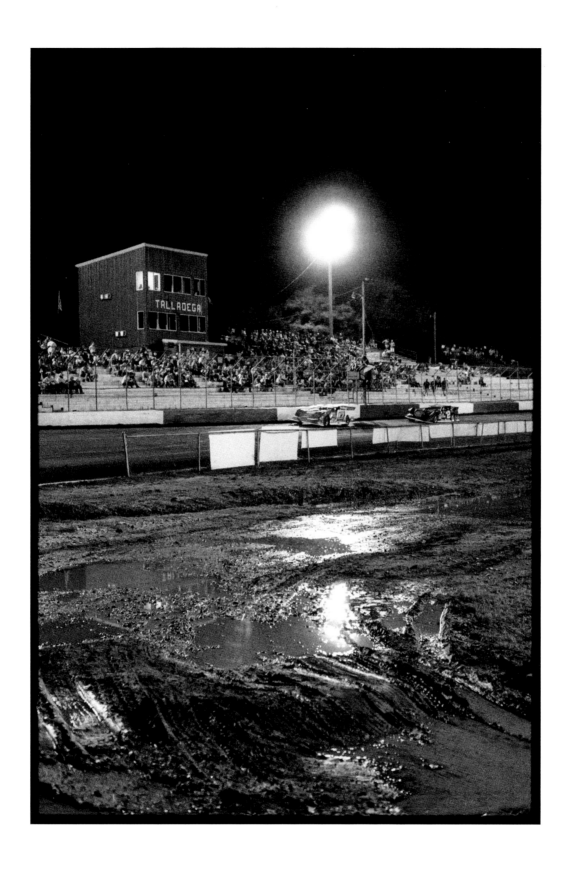

TALLADEGA INFIELD

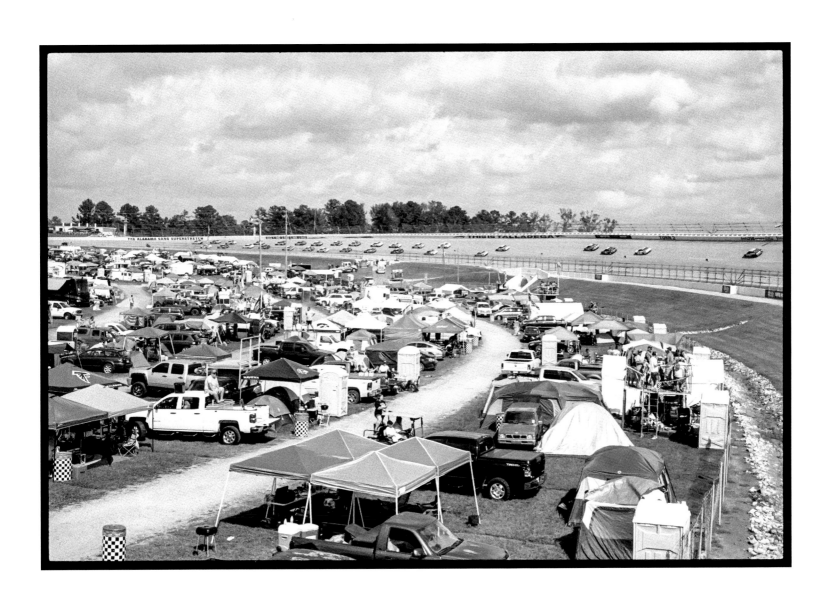

NORTH CAMP

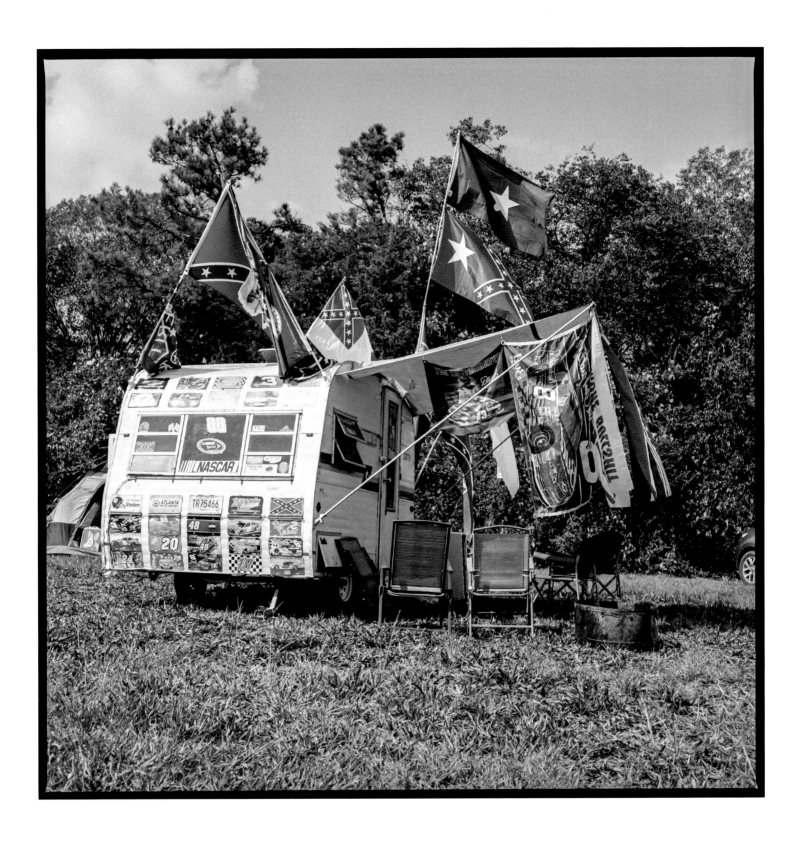

DUST CAMP

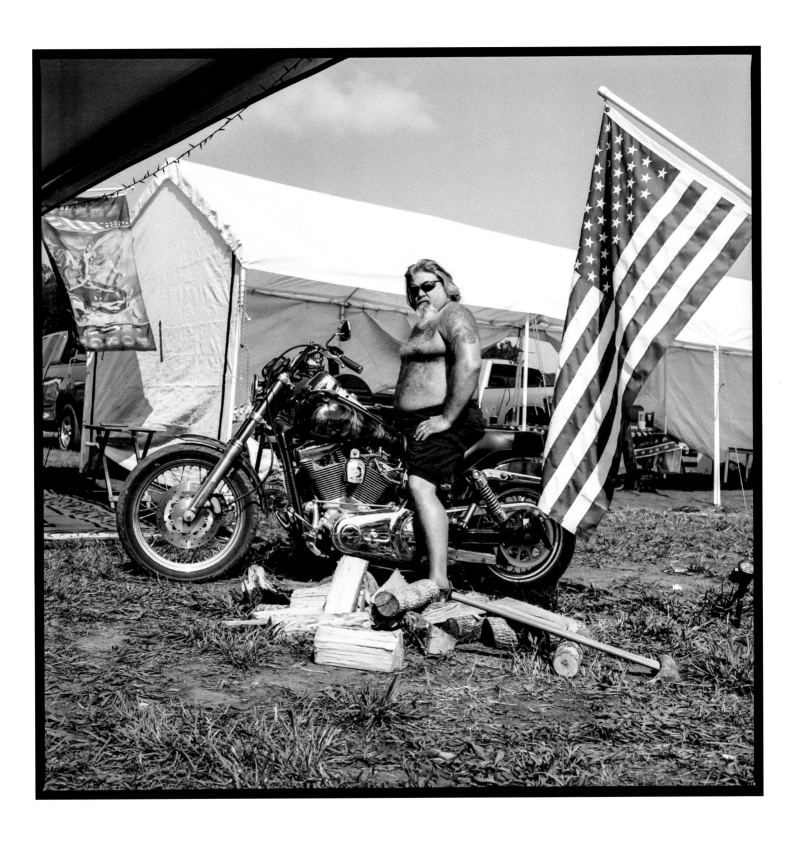

ASPEN

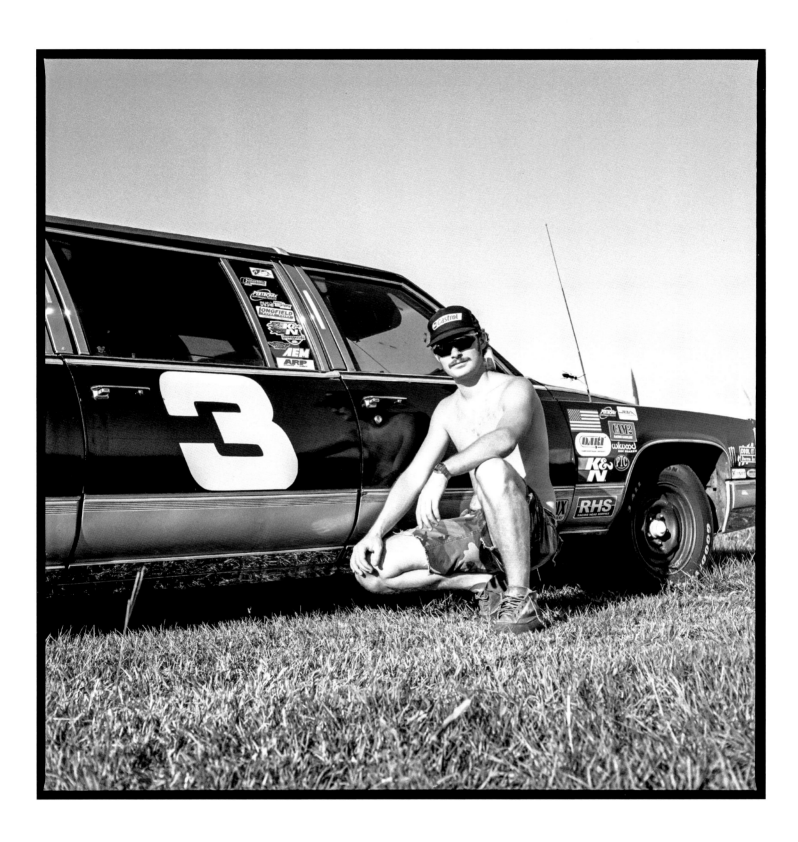

TRACK OFFICIAL

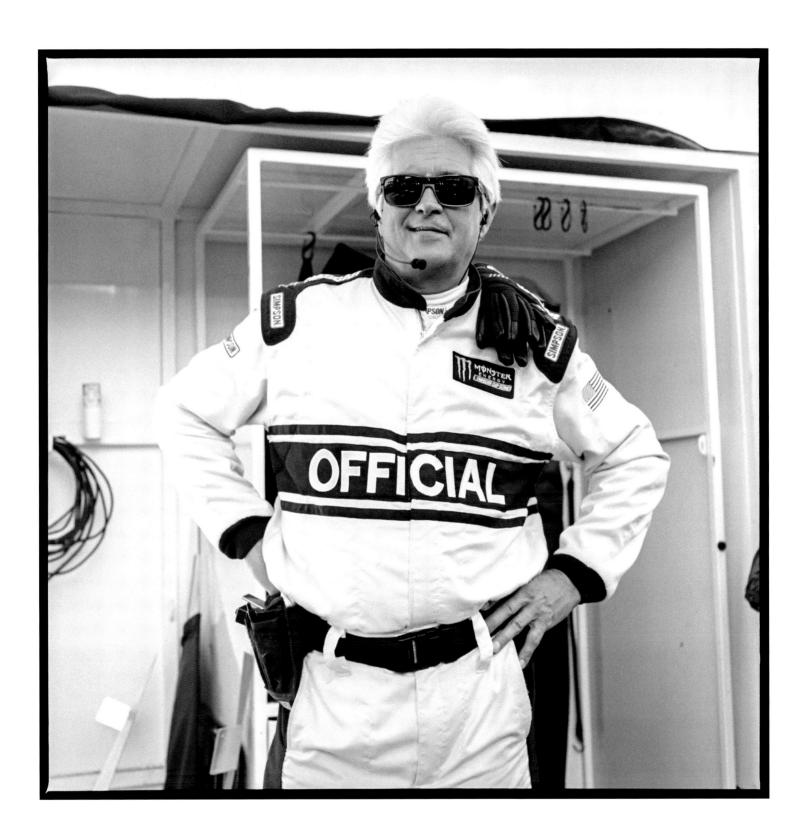

THE MORNING OF THE RACE

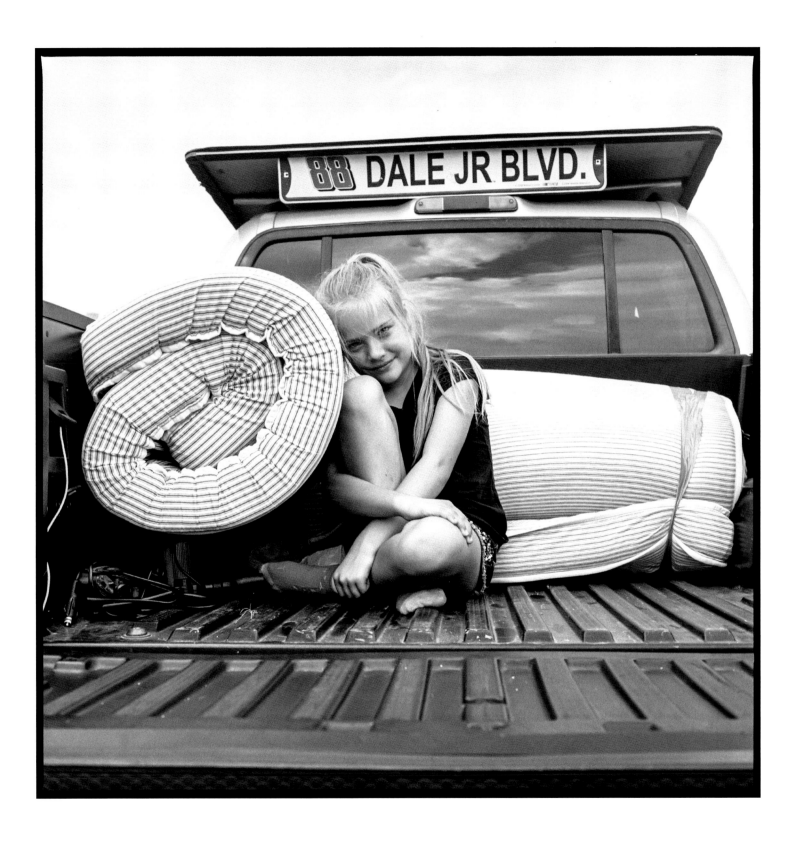

DALE EARNHARDT JR.

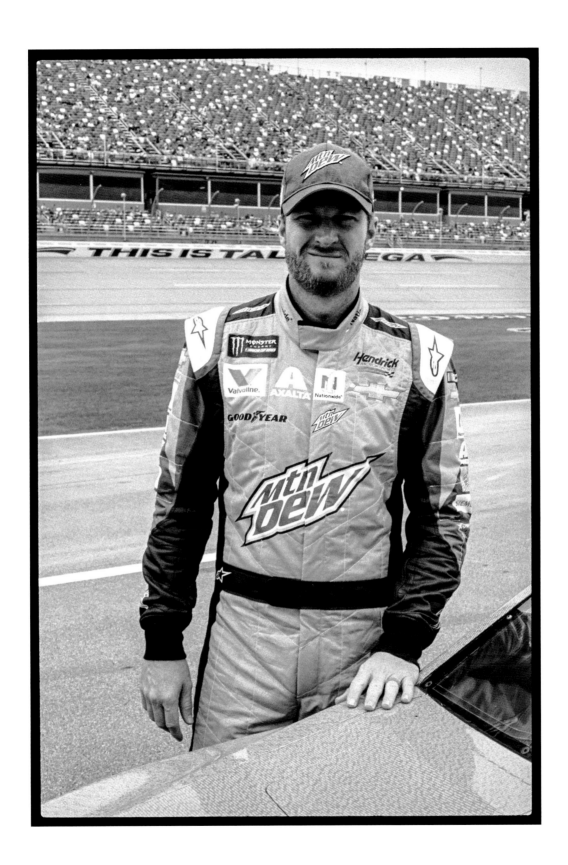

ERIC AND BRITTANY

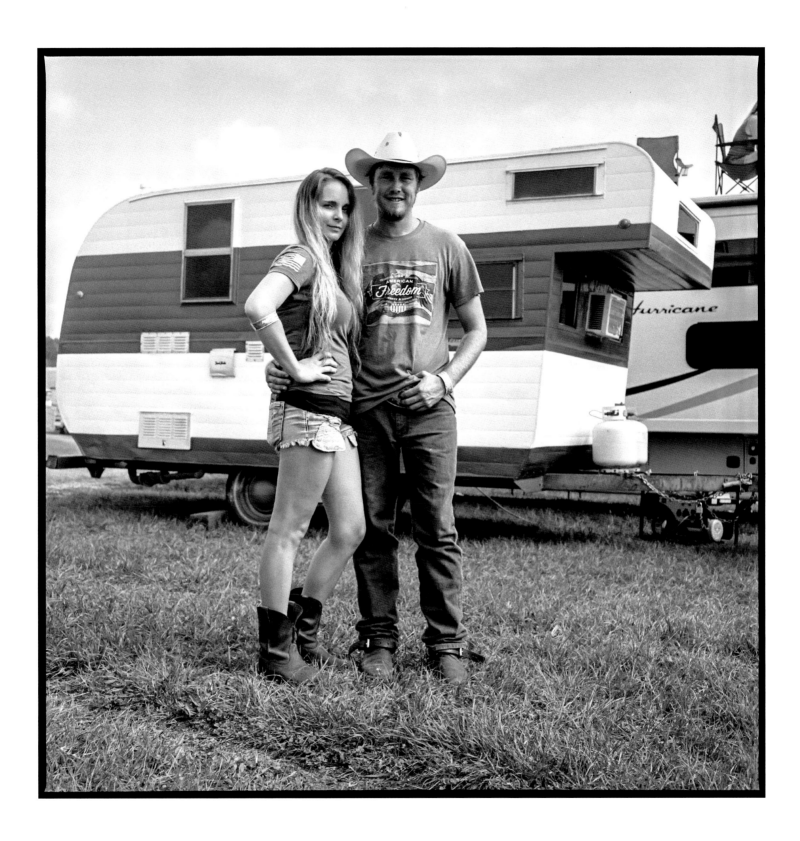

NORTH CAMP SETUP

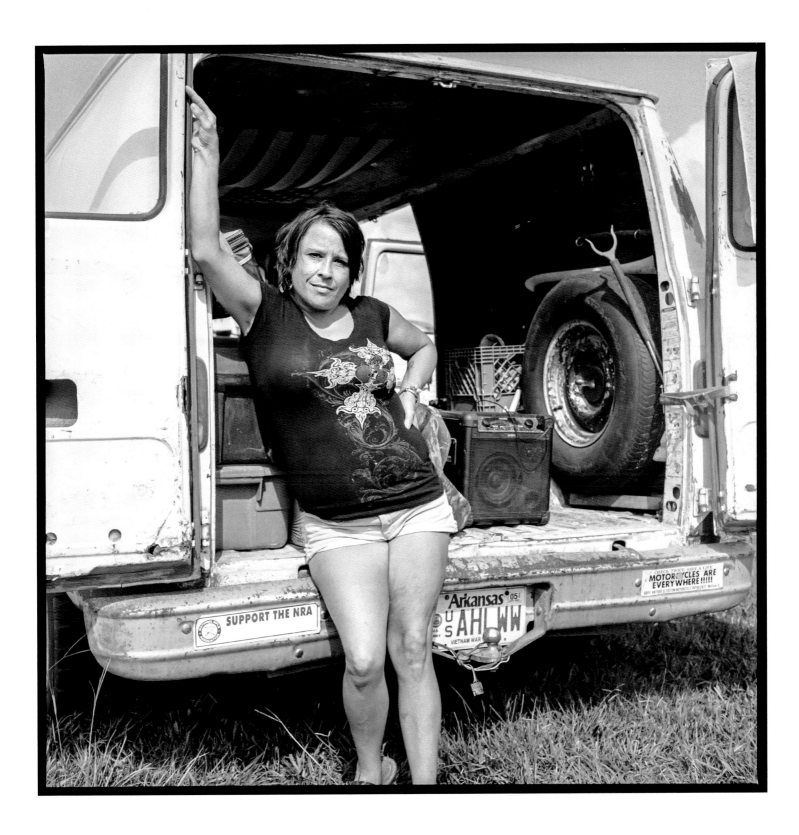

JIM HUTCHINS

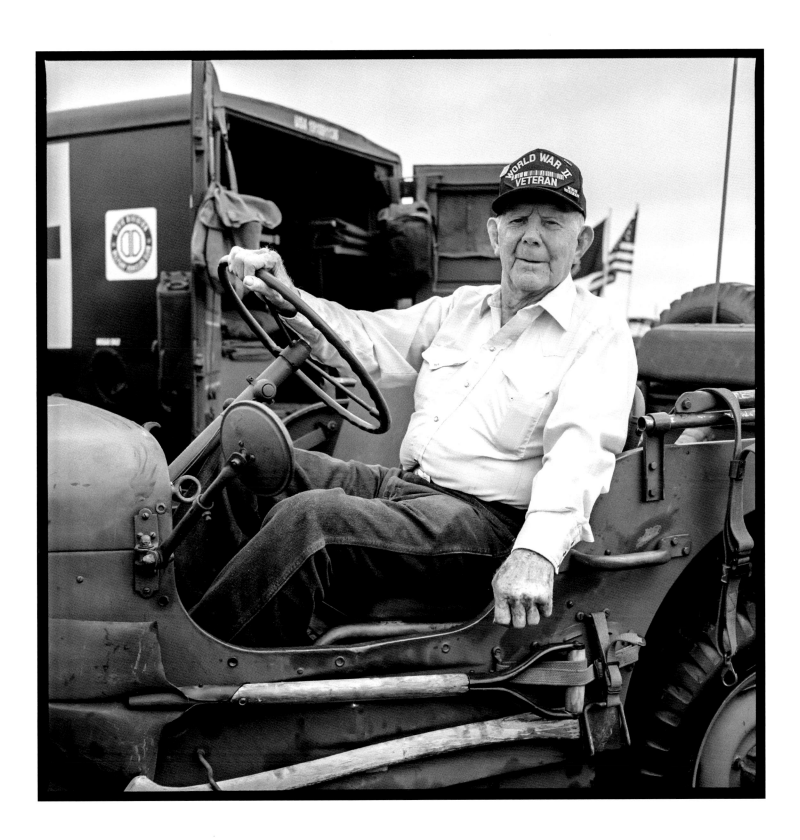

DEGA

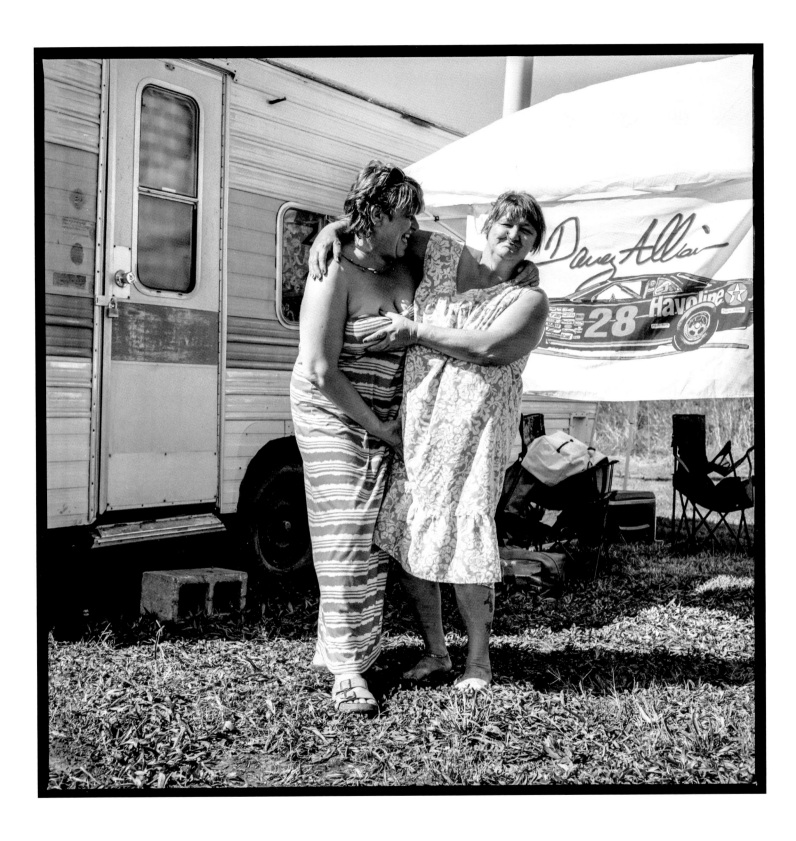

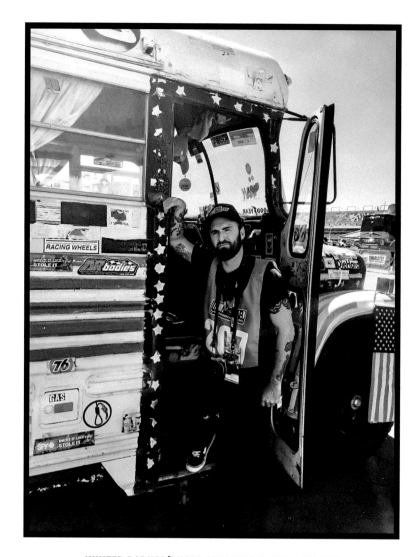

HUNTER BARNES (B. 1977)

Hunter's photographs document aspects of culture and communities ignored by the mainstream and often misrepresented in the modern American narrative. In his early twenties, Hunter self-published his first book, *Redneck Roundup*, documenting the dying communities of the Old West. Other projects followed: four years spent with the Nez Perce tribe; months with a serpent handling congregation in the Appalachian mountains; bikers, lowriders, and street gangs; inmates in California State Prison. Intense, true pockets and sub-cultures of America. Hunter shoots exclusively on film, the pace of analogue in harmony with his approach. Fundamental to Hunter's work is the journey, the people, the place. Then committing them to film before they are greatly changed or gone forever.

These photographs were shot in 2017 in Daytona Florida, Bristol Tennessee, Darlington South Carolina, Charlotte North Carolina, North Wilkesboro North Carolina and Talladega Alabama.

THANK YOU

NASCAR
Dave Dingman
The Dingman Family
Jack Roush
Chip Ganassi Racing
Max Jones
John Oldguin
Davis Shaefer
All the Ganassi team
Everyone in the book
All the fans
All the drivers
Terry Parsons
Janet Kirkley
Robert Johnson
Mr Paul Call
North Wilkesboro Speedway
NASCAR Hall Of Fame
Wendy Belk
Kevin Larrabee
Gary Ramsey
George Merck

Andrea Castagno and August Eagle
My Mom and Dad
All My Family
John Lansing
Jason Cannon
Velem
Mazdack Rassi
Milk Studios
Dave Damico
Milk Digital
Zach Adams
Haas Colby
Tony Nourmand
Reel Art Press
Alison Elangasinghe
Dave Brolan
Rory Bruton
Joakim Olsson
Lisa Baker
David Hill
The Talladega short track
Mena May

Eric Borgerding
Josh Ayers
Joseph Baldassare
Antonio Velverde
Erin Wasson
Noot Seear
John Bell
Travis David
Steve Rifkin
Everyone at Hanks Photographic
Justin King
LTI Light Side
Tiffany Powers
Heather Lumpp
BC Taxi in Talladega
Everyone I met and guided me
Jeff Pinkus
Gibby Haynes
Charlotte Kidd
Jordan Ford
Jackie Bolin and Mark Kuonen
Wendi Sturgis and Alex Yong

Edited by Tony Nourmand, Hunter Barnes and August Eagle
Art direction and design by Joakim Olsson
Image scanning and retouching by Haas W. Colby / Velem
Image production and archiving by Zach Adams / Milk Digital
Pre-press by HR Digital Solutions

First published 2019 by Reel Art Press,
an imprint of Rare Art Press Ltd, London, UK

www.reelartpress.com

First Edition
10 9 8 7 6 5 4 3 2 1

ISBN: 978-1-909526-64-8

Printed by Graphius, Gent.

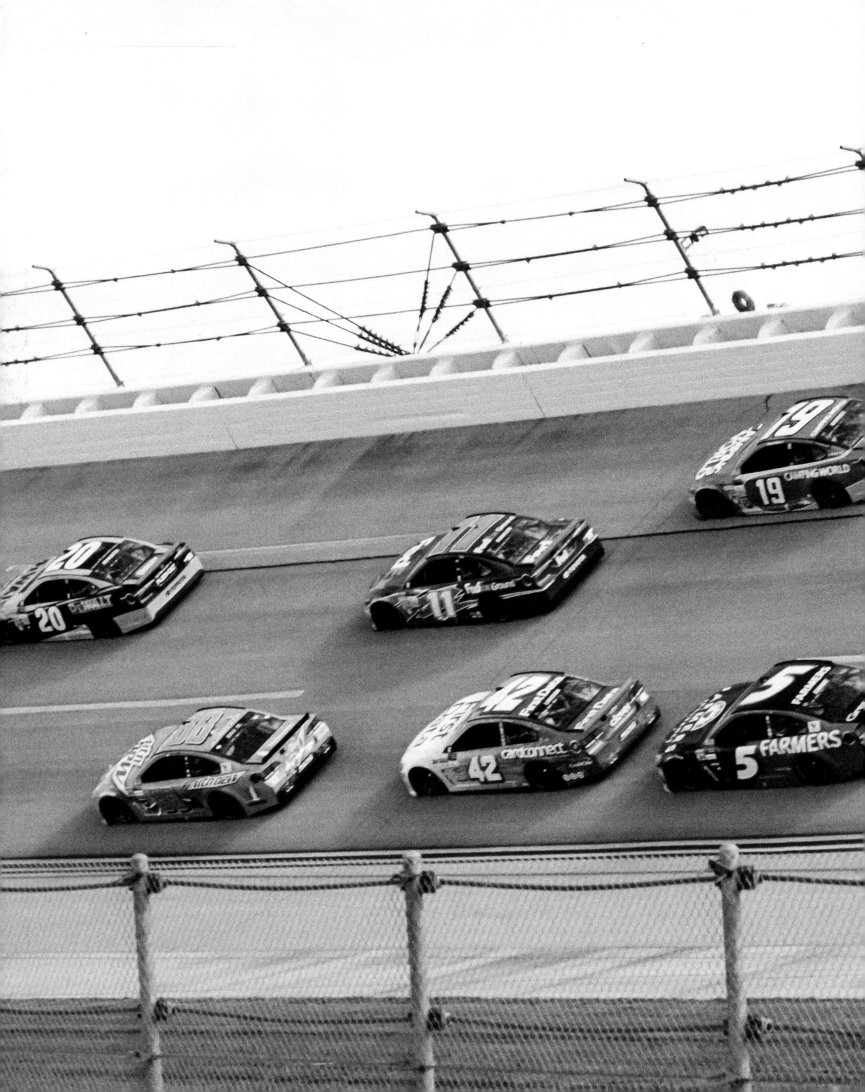